Photographing Indoors With Your Automatic Camera

BARBARA LONDON / RICHARD BOYER

Curtin & London, Inc.
Somerville, Massachusetts

Van Nostrand Reinhold Company
New York Cincinnati Toronto Melbourne

Printed in the United States of America

Published in 1981 by Curtin & London, Inc.
and Van Nostrand Reinhold Company
A division of Litton Educational Publishing, Inc.
135 West 50th Street, New York, NY 10020, U.S.A.

Van Nostrand Reinhold Limited
1410 Birchmount Road
Scarborough, Ontario MlP 2E7, Canada

Van Nostrand Reinhold Pty. Ltd.
17 Queen Street
Mitcham, Victoria 3132, Australia

Interior and cover design: David Ford
Cover photograph: Lou Jones
Art and production manager: Nancy Benjamin
Illustrations: Omnigraphics
Photo research: Lista Duren
Composition: P & M Typesetting, Inc.
Printing and binding: Kingsport Press
Paper: 70# Patina, supplied by Lindenmeyr Paper Co.
Covers: Phoenix Color Corp.

Material from charts for suggested exposures adapted from Eastman
Kodak Company.

10 9 8 7 6 5 4 3 2 1

Library of Congress Cataloging in Publication Data

London, Barbara.
 Photographing indoors with your automatic camera.

 Includes index.
 1. Photography, Indoor. I. Boyer, Richard,
joint author. II. Title
TR620.L66 1981 778.72 80-26160
ISBN 0-930764-18-8

Contents

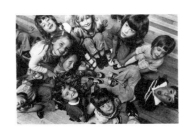

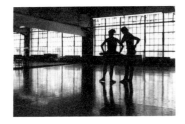

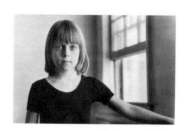

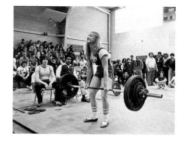

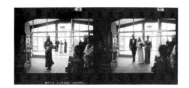

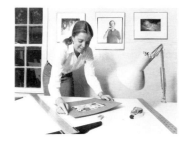

Preface

Great photographs indoors are getting easier to take. More exciting photographs—using the rich variety of available light, the warmth of candlelight or firelight, or the action-freezing ability of the modern electronic flash—are possible when you know how to take advantage of your automatic 35mm single-lens-reflex camera and its accessories. These new automatic cameras, with their built-in exposure controls and automatic flash units, have greatly simplified indoor photography. Used with modern high-speed lenses and fast color films, new horizons have opened up for the creative photographer. No longer do you have to lose the spontaneity of candid photography while measuring distances for your flash or making light readings for your exposure. With your automatic camera set, you can instantly capture all of the action, no matter how fleeting, as it unfolds.

Indoor photography has its own unique subtleties and techniques that separate really good photographs from the run-of-the-mill shots taken by the millions each year. A few simple, easy-to-learn techniques, combined with your high-quality automatic camera and a thoughtful approach, can make your photographs more exciting and satisfying.

The purpose of this book is to show you how to take better pictures indoors, using either available light or electronic flash. It specifically covers automatic cameras and their use in portrait, sports, still life, and close-up photography and much, much more. It shows how to get those great single images of people and things and also shows how to use a series of photographs to tell a story effectively. Finally, the book tells you how to organize and display your photographs, either slides or prints, to maximum advantage.

Just a few of the many topics covered are:

> When and how to override your automatic exposure system

> Qualities of light indoors

> Automatic flash and its uses

> Photographing people

> Sports and recreation

> Close-ups and still lifes

> Picture stories

> Preserving and showing your pictures

Special symbols, located at the bottom of some pages, are designed to remind you of points of special importance.

📷	Camera	🔺	Camera Supports
🔘	Lenses	⚙	Aperture (f/stops)
O	Lens Attachments	◐	Shutter Speeds
🎞	Film	▥	Exposure Compensation
📸	Automatic Electronic Flash		

1 Automatic Photography Indoors

David Aronson

Your Automatic Camera

If you have used an automatic 35mm SLR (single-lens reflex) camera, you know how simple photography can be with it. The camera meters the brightness of the scene you are viewing, then sets the shutter speed and/or aperture to let the right amount of light into the camera. In average scenes, all you have to do to get a correctly exposed picture is simply focus and shoot. But there are some non-average scenes where the automatic system does not work well—for example, a spotlit circus act against a dark background. This book identifies those times when you should override the automatic system and tells you how to do so (see pp. 12–15). The book also tells how to expand your picture-making skills indoors using camera controls such as shutter speed, aperture, and focus.

The shutter speed control selects the length of time that light enters the camera. This affects the exposure, the light that reaches the film. The shutter speed also affects whether a moving subject will appear sharp or blurred. (See pp. 10–11 for more about shutter speed and motion.)

The aperture control adjusts the size of the lens opening controlling the brightness of light that enters the camera. This affects the exposure as well as depth of field, how much of a scene will be sharp in the final photograph. (See pp. 8–9 for more about aperture and depth of field.)

The focus control determines which part of the scene will be the sharpest. As you turn the focus control, the viewfinder shows which area is focused sharply.

An automatic electronic flash is an easy way to add light to a scene when the existing light in a room is too dim. A sensor on the flash reads the light reflected back from the subject and cuts off the flash when the exposure is correct. (For how to use flash see pp. 36–47.)

Interchangeable lenses allow you to change your view of a scene by changing lenses. A wide-angle (short-focal-length) lens can show an entire room wall to wall; a telephoto (long-focal-length) lens can enlarge a detail of an object at a distance. (See pp. 16–17 for more about lenses.)

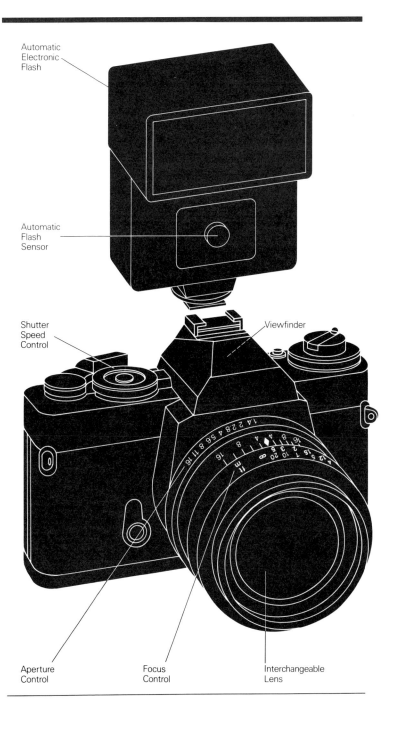

Automatic Electronic Flash

Automatic Flash Sensor

Shutter Speed Control

Viewfinder

Aperture Control

Focus Control

Interchangeable Lens

Automatic Exposure Indoors

Automatic exposure works well because although the objects in each scene are different, most scenes include a few dark shadows, mostly tones of medium brightness, and a few bright highlights. Altogether, each scene averages out to a tone called middle gray. Your camera operates by measuring the overall brightness of the scene, then letting in enough light to produce a middle gray tone on the film you are using.

The camera—and you—can use two controls to adjust the amount of light entering the camera: shutter speed and aperture. In aperture-priority operation, you set the aperture (the size of the lens opening) and the camera selects the appropriate shutter speed for a normal exposure. In shutter-priority operation, you set the shutter speed, and the camera selects the aperture. Some cameras have a completely automatic, programmed mode that sets both shutter speed and aperture for you. In manual operation, you select both the shutter speed and aperture yourself.

An automatic single-lens reflex camera lets you view directly through the lens. In automatic operation it measures the brightness of the scene, then selects the shutter speed or aperture that will produce a correct exposure for your film.

The camera's viewfinder gives you a view of the scene that will be on film. Part of the light is diverted to a light-sensitive cell that measures the brightness of the scene. The viewfinder also shows exposure information; this one displays shutter speed and aperture settings.

David A. Krathwohl

You can trust your automatic exposure system to produce a good exposure indoors when the subject in the viewfinder is of average tonal range. Automatic exposure tends to work well in evenly diffused light from several light sources (above) and in light that comes from more or less behind the camera and illuminates both the main subject and its background (below). In some situations, like backlit scenes, automatic exposure does not always work well; pp. 12–13 tells when and how to override the automatic system.

Fredrik D. Bodin

Automatic Exposure: Aperture Priority

In aperture-priority operation, you select the aperture and the camera automatically sets the correct shutter speed. The aperture, an adjustable opening inside the lens, can open wider to let in more light or "stop down" to let in less. Which aperture you select is important because its size affects the depth of field, the distance from near to far parts of the scene that will appear sharp in the photograph. At small apertures more, sometimes all, of the scene from foreground to background will be sharp. At large apertures, less will be sharp. (See opposite.)

The size of the aperture and the speed of the shutter are coordinated: if you let in more light with one, the other automatically changes to let in less. So in aperture-priority operation you can also select the shutter speed, but you have to do so indirectly. If you want a faster shutter speed, select a wider aperture; the wider aperture lets in more light, so the shutter automatically operates faster. If you want a slower shutter speed, choose a smaller aperture.

Aperture settings are numbered in f-stops: f/1.4, f/2, f/2.8, f/4, f/5.6, f/8, f/11, f/16, f/22, f/32, f/45 (no lens has all the settings). The smaller the number the larger the aperture opening. Each setting is one "stop" from the next setting; it lets in twice as much light as the next smallest setting. For example, f/5.6 lets in twice as much light as f/8, and half as much as f/4. On some lenses the largest setting may be between steps on the scale—f/3.5, for example, instead of f/4.

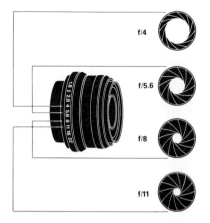

Barbara Alper

Depth of field, the depth in a scene that is sharp in a photograph, is affected by the size of the lens aperture. Above: a wide lens aperture, f/2.8, produced little depth of field; only the woman's face and hand are sharp. Below: a small aperture, f/16, produced considerable depth of field; the foreground, the man, and the background are all sharp. Other factors besides aperture affect the depth of field; see p. 56.

If you look through the camera's viewfinder as you change the aperture, the depth of field will not appear to change. This is because the viewfinder displays the scene at the widest aperture. When you take the picture, the camera will automatically stop down. Some cameras have a depth-of-field preview button that lets you view the scene at the shooting aperture.

Barbara Alper

Automatic Exposure: Shutter Priority

In shutter-priority operation you select the shutter speed and the camera automatically selects the correct aperture. The length of time that the shutter is open affects the way that motion is shown in a photograph. Slower speeds leave the shutter open long enough for a moving subject to blur; at faster speeds a moving subject will be sharp because the shutter opens and closes before the subject has moved far enough to blur. (See opposite.) Other factors, such as the direction that the subject is moving, also affect the way it will appear; see pp. 70–73.

Control of the aperture is possible even in shutter-priority operation by changing the shutter speed. If you set the shutter speed slower, the camera will automatically change the aperture to a smaller one. If you select a faster shutter speed, the aperture will be wider.

Shutter speed settings are arranged so that each speed lets in twice the amount of light as the next fastest setting: 1 sec, 1/2 sec, 1/4, 1/8, 1/15, 1/30, 1/60, 1/125, 1/250, 1/500, 1/1000. (At fractions of a second, only the bottom number of the fraction appears on a shutter speed dial or in a viewfinder display.) Other settings include X for flash pictures and B for long exposures during which the shutter remains open as long as the shutter release button is depressed.

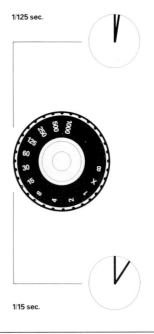

1/125 sec.

1/15 sec.

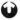

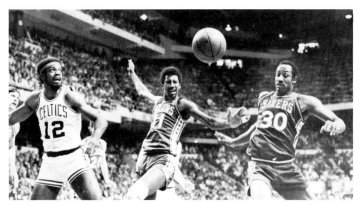

The shutter speed affects the way a moving subject appears in a photo-graph. At a fast shutter speed (above) players and ball are frozen sharp in mid-play. At least 1/250 sec would be needed to record this scene sharply; 1/500 sec would be safer. A fast shutter speed also prevents the blur (below) that can occur when a camera is hand held during a long exposure. Even slight motion of the camera during a long exposure can cause the entire picture to look out of focus. If you want to hand hold the camera, make sure your shutter speed is at least as fast as the focal length of the lens you are using: 1/60 sec for a 50mm lens, 1/125 sec for a 105mm lens, and so on.

When and How to Override Automatic Exposure Indoors

It is relatively easy to predict what an automatic exposure system will do because it always "thinks" in the same way. It assumes that if the brightnesses in any scene are averaged, they will always be a middle gray tone, and it exposes the film accordingly. This usually works well because there are only three types of scenes in which an exposure for middle gray will not give good results.

> A subject surrounded by a much brighter background, for example, a portrait against a bright window. The automatic system will be overly influenced by the bright background and will underexpose the scene so that your subject is too dark. In this type of scene, use exposure compensation to increase the exposure.

> A subject surrounded by a much darker background, for example, a spotlit act on a dark stage. The camera will try to bring the entire scene up to middle gray, and as a result the main subject will be overexposed and too light. Use exposure compensation to decrease the exposure.

> An entire scene that is much lighter or much darker than middle gray, for example, a close-up of white lace (the camera will expose for middle gray and the picture will be too dark) or a black tuxedo (the camera will expose for middle gray and the scene will be too light). Use exposure compensation to lighten a scene that is very light overall or darken one that is very dark overall.

Exposure compensation is needed most with color slide film because the film in the camera is the end product that you view. Some correction during printing is possible with color negatives and even more is possible with black-and-white negatives, but exposure compensation is still desirable.

All cameras have one or more means of overriding the automatic exposure ▶
system when you want to increase the exposure to lighten a picture or decrease the exposure to darken it. The change in exposure is measured in "stops." Each aperture setting is 1 stop from the next setting. Shutter speeds are also described as being 1 stop apart; each setting is 1 stop from the next.

Memory Lock
A memory lock temporarily locks in an exposure so you can move up close to take a reading of a particular area, lock in the desired setting, step back, and then photograph the entire scene. Only a few of the more expensive cameras have this device.

Backlight Button
Depressing a backlight button adds a fixed amount of exposure (usually 1 to 1½ stops) and lightens the picture. It cannot be used to decrease exposure. A camera may have this device if it does not have an exposure compensation dial.

Exposure Compensation Dial
Moving the dial to +1 or +2 increases the exposure and lightens the picture (some dials say X2 or X4 for equivalent settings). Moving the dial to −1 or −2 (X½ or X¼ on some dials) decreases the exposure and darkens the picture.

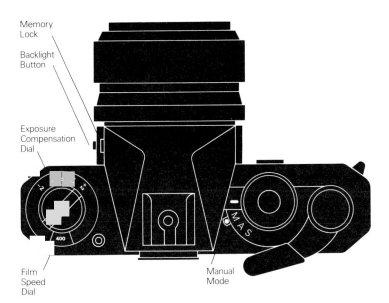

Memory Lock
Backlight Button
Exposure Compensation Dial
Film Speed Dial
Manual Mode

Film Speed Dial
You can increase or decrease exposure by changing the film speed dial. The camera then responds as if the film is slower or faster than it really is. With ASA or ISO-rated film, doubling the film speed (for example, from ASA 100 to ASA 200) darkens the picture by decreasing the exposure one stop. Halving the film speed (for example,

from ASA 400 to ASA 200) lightens the picture by increasing the exposure one stop. (With European DIN-rated films, every increase of 3 in the rating is the same as doubling an ASA-rated film. DIN 21 is equivalent to ASA 100; DIN 24 is equivalent to ASA 200.) Even if a camera has no other means of exposure compensation, you can always use the film speed dial.

Manual Mode
In manual mode, you adjust the shutter speed and aperture yourself. Exposure can be increased to lighten the picture or decreased to darken it as you wish. Many cameras have a manual mode though some less expensive models do not.

Quick Guide to Exposure Compensation

Number of Stops from Automatic Setting	+2	+1
When to Use	**Increase the exposure 1 stop for**	
	• Sidelit or backlit scenes	
	• Scenes that include bright light source (such as a window)	
	• Natural rendition of very light objects (such as a white cat on a white pillow)	
Use only one of these techniques to increase or decrease exposure	**Increase the exposure 2 stops** when the light is extremely contrasty and important shadowed areas are much darker than brightly lit ones.	

Camera on Manual

	+2	+1
Changing Aperture Lighten ⎯⎯ Darken 5.6 8 11 16 22	Open up two stops (Example—from f/11 to f/5.6)	Open up one stop (Example—from f/11 to f/8)
Changing Shutter Speed Darken Lighten	Reduce shutter speed by two stops (Example—from 1/60 to 1/15)	Reduce shutter speed by one stop (Example—from 1/60 to 1/30)

Camera on Automatic

	+2	+1
Exposure Compensation Dial Lighten Darken	Move exposure compensation dial to +2 (or X4)	Move exposure compensation dial to +1 (or X2)
Changing Film Speed Lighten Darken	Reduce ASA or ISO setting by ¾ (Example—from ASA 400 to ASA 100). Or reduce DIN setting by 6 (Example—from 18 to 12)	Reduce ASA or ISO setting by ½ (Example—from ASA 400 to ASA 200). Or reduce DIN setting by 3 (Example—from 18 to 15)

0	−1	−2
Use the exposure set automatically for scenes that are evenly lit as viewed from camera position and when important shadowed areas are not too much darker than brightly lit ones.	**Decrease the exposure 1 stop for** ● Scenes where the background is much darker than the subject (such as a portrait in front of a very dark wall) ● Natural rendition of very dark objects (such as a black cat on a black pillow) **Decrease the exposure 2 stops** for scenes of unusual contrast, as when an extremely dark background occupies a very large part of the image.	
Leave aperture unchanged	Close down one stop (Example—from f/11 to f/16)	Close down two stops (Example—from f/11 to f/22)
Leave shutter speed unchanged	Increase shutter speed by one stop (Example—from 1/60 to 1/125)	Increase shutter speed by two stops (Example—from 1/60 to 1/250)
Leave exposure compensation dial unchanged	Move exposure compensation dial to −1 (or X½)	Move exposure compensation dial to −2 (or X¼)
Leave film speed setting unchanged	Multiply ASA or ISO setting by 2 (Example—from ASA 400 to ASA 800). Or increase DIN setting by 3 (Example—from 12 to 15)	Multiply ASA or ISO setting by 4 (Example—from ASA 400 to ASA 1600). Or increase DIN setting by 6 (Example—from 12 to 18)

Lens Basics

The single most important characteristic of a lens is its focal length. The longer the focal length (in millimeters, mm) of the lens you are using, the more that the lens will enlarge an object and the narrower the view of a scene that it will show (see below and opposite). Most cameras are sold with a 50mm, normal-focal-length lens. The widest views are given by short-focal-length (or wide-angle) lenses, which are useful when photographing in small rooms or close to a subject. Narrower views (and enlarged images) are produced by long-focal-length (or telephoto) lenses; they are useful for enlarging objects at a distance, for example, when photographing an athlete from across a playing court. Extremely long focal lengths, such as 1000mm, are not as useful indoors as they are outdoors because you are seldom so far away from your subject that you need them. A zoom lens combines a range of focal lengths, such as 35–70mm; the focal length is adjustable so that you can shoot at any focal length within that range.

A fast lens, one that opens to a wide maximum aperture, may be useful if you often shoot in dim light or at fast shutter speeds (see p. 69).

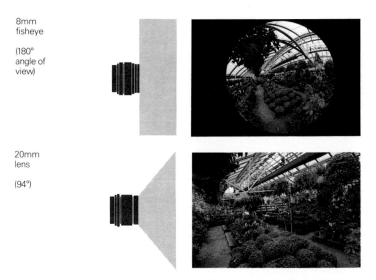

8mm
fisheye

(180°
angle of
view)

20mm
lens

(94°)

35mm
lens

(62°)

50mm
lens

(46°)

105mm
lens

(23°)

200mm
lens

(12°)

400mm
lens

(6°)

Alan Oransky

Film for Indoor Use

Although the array of films available in any photo store may seem somewhat imposing, the films actually fall into several broad categories:

Black-and-white or color. If you want a color film, there are two basic types: daylight balanced and tungsten balanced. Use daylight film indoors if the main light source is from a window during the day, from fluorescent lights, or from flash. Use tungsten film if the main light source is from household lamps or other tungsten sources or from candlelight or firelight. See pp. 24–25 for more about color balance and film.

Prints or slides. Shoot negative film if you want prints; color negative film usually has "-color" in the name as in Kodacolor or Fujicolor. Shoot reversal or transparency film if you want slides; color slide film usually has "-chrome" in the name as in Kodachrome or Agfachrome. You can, if you wish, get a print made from a slide.

Fast (high film speed) or slow (low film speed). Film speed (see box below) indicates the relative sensitivity of a film to light. Since light indoors is seldom as bright as it is outdoors, most indoor photography is with fast film, which requires less light for a good exposure. (See opposite.)

There are several systems for rating film speed. An ASA or ISO rating is commonly found on films and camera equipment in English-speaking countries. Each time the rating doubles, the speed of the film doubles. ASA 200 film is twice as fast as ASA 100 film, and half as fast as ASA 400 film.

A DIN rating is often found on European film. Each time the rating increases by 3, the speed of the film doubles. A film rated DIN 24 is twice as fast as a film of DIN 21, and half as fast as a film rated DIN 27.

A long version of the ISO rating is sometimes seen. It combines the ASA and DIN numbers—for example, ISO 200/24°, ISO 100/21°. Simply use the half of the rating that is suitable for your camera equipment.

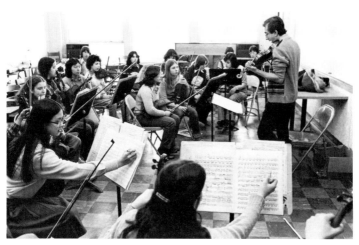

Fredrik D. Bodin

▲ *A fast film (one with a high film speed) is more sensitive to light than is a slow film. It needs less light for a good exposure and so can be used at a faster shutter speed (or at a smaller aperture) than can a slow film. It is usually a good choice for indoor photography, especially when people are moving and you want to have the picture sharp. Above: a fast film, one with a film speed rating of ASA or ISO 400 (DIN 27) or higher would be useful in a situation like this where the photographer wanted unposed shots of a youth orchestra as they were rehearsing.*

▼ *A slower film might be your choice for certain scenes. Slower films tend to have less graininess in the image than do fast ones and to show colors and details better. Below: a medium or slow film, ASA or ISO 100 (DIN 21) or slower would be a good choice for this still life of antique clothing.*

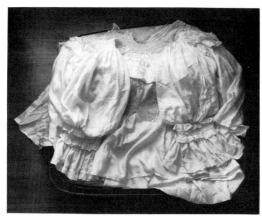

Eric Myrvaagnes

2 Lighting

Qualities of Light Indoors

Light varies tremendously indoors, from hard-edged and contrasty to delicate and soft. Light affects the way your subject will look in the final picture; it influences the color of the image, the texture and detail, even the overall mood and feeling. This chapter shows the light you can expect to find indoors—how its contrast (below), color (pp. 24–25), and direction (pp. 26–27) affect your pictures and how you can control light to get better results. Chapter 3, pp. 36–47, tells how to use electronic flash lighting.

The contrast in a scene—the difference between dark shadows and bright highlights—will often be more noticeable in the final photograph than it appeared when you were taking the picture. Film, particularly color slide film, accurately records details and colors for only a limited range of brightnesses; for example, either a brightly lit face or dark surrounding shadows, but not both in the same picture.

Automatic exposure works well when the light on a scene is relatively even and the contrast between shadows and highlights is low (see below). If the contrast is high, your camera's automatic system will be influenced by the dominant part of the scene (see opposite and p. 12).

Light from several fixtures illuminated this toy store display. The light came from different directions—from both sides and from overhead. As a result, the contrast in the scene (the difference in brightness between shadows and highlights) was low. Automatic exposure works well in situations like this where the scene, as viewed from camera position, is more or less evenly illuminated.

Fredrik D. Bodin

Bobbi Carrey

Above: light from a single window created dark shadows and high contrast between light and dark areas. When dark shadows occupy this much of a scene, your automatic camera will tend to overexpose the picture and make it too light (see p. 12). Try using exposure compensation to decrease the exposure about 1 stop (see pp. 13–15). You could also move in close to meter the more important, lit side of the face, then set the shutter speed and aperture manually. Below: if you photograph a subject (the dancers) against an exceptionally bright background (the windows and reflections), your automatic camera will tend to underexpose the scene. The subject may be too dark if you want to see details. Here the photographer deliberately underexposed the scene to silhouette the subjects.

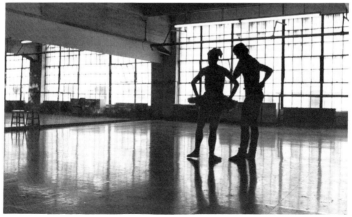

Jerry Howard

Color of Light Indoors

For the most realistic color reproduction, match your color film to the type of illumination: use daylight-balanced color film in bluish light, tungsten-balanced (indoor) color film in reddish light (more about film on pp. 18–19). Matching film to light source is most important with color slides because the film in the camera is the end product that you view after processing. Most color prints can be adjusted somewhat when the prints are made.

Light sources vary in color. Some, such as daylight and electronic flash, have a relatively large amount of blue light rays; others, such as tungsten light and firelight, have a relatively large amount of red rays. This color balance can be measured and arranged on a scale (Kelvin or K degrees) somewhat like a thermometer.

Color film is more sensitive to shifts in color than our eyes are and is balanced to render colors accurately only within a narrow range. Daylight-balanced color film produces the most natural colors when used with bluish light sources; tungsten-balanced color film looks best with reddish light sources. See comparisons opposite.

Film	Color Temperature	Type of Light
	12,000 K and higher	Clear skylight in open shade, snow
	10,000 K	Hazy skylight in open shade
	7000 K	Overcast sky
	6600 K	
	5900-6200 K	Electronic flash
Daylight	5500 K	Midday
	4100 K	
	3750 K	
	3600 K	
	3500 K	
Type A (indoor)	3400 K	Photolamp
Tungsten (indoor)	3200 K	
	3100 K	Sunrise, sunset
	3000 K	
	2900 K	100 watt tungsten bulb
	2800 K	
	1900 K	Candlelight, firelight

25

Fredrik D. Bodin

Bluish light sources *such as light from a window during the day or from an electronic flash or a carbon arc lamp used in a theatrical spotlight produce natural colors with daylight-balanced color film (left). Tungsten-balanced film used with these lights will make colors look too blue (right).*

Fredrik D. Bodin

Reddish light sources *such as household lamps and photoflood bulbs record colors best on tungsten-balanced color film (left). Daylight films used with these sources shift colors to reddish tones (right).*

Fredrik D. Bodin

Fluorescent and mercury-vapor lamps *produce a greenish light (left) that varies from source to source, so it is difficult to assess. Daylight-balanced color film is recommended. For best color balance with fluorescent lighting try daylight film plus a magenta FL-D or CC30M filter (right).*

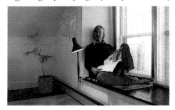 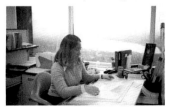

Fredrik D. Bodin

Mixed light sources *illuminate a scene with light of more than one color. In daylight scenes with tungsten light, the bluish window light usually dominates so daylight film is best (left). Daylight film also minimizes the greenish cast with fluorescent plus other light sources (right).*

Direction of Light Indoors

The direction that the main source of light is coming from as seen from camera position has an important effect on your subject. Light that comes from the side emphasizes textures and volumes; light that comes from the front or back minimizes them (see pp. 98–99). Try looking at your subjects from several different positions or moving them relative to the source of light. You may find that a different position is more pleasing.

Jon Cooper

Above: front lighting, light that comes from the direction of the camera (such as a flash unit mounted on the camera), minimizes the shadows that are visible from camera position and so minimizes surface detail such as skin texture. Right: side lighting (such as a lamp to one side of your subject) emphasizes textures and volumes because as the light rakes across the subject it casts shadows that pick out surface details.

Brian Alterio

Marjorie Masel

Above: as the main light (as seen from camera position) moves farther behind the subject, texture and volume continue to be emphasized, but important parts of the subject—here, the face—may go into shadow. Below: light that is directly behind the subject will silhouette it. Here, a rim of light outlines the subject. A more common effect is a dark silhouette against a very light background such as a bright window.

Jerry Howard

Available Light Sources

The most unobtrusive way to photograph indoors is to use the light already available in the room. With fast film (ASA or ISO 400, DIN 27) and a wide aperture (f/2.8 or wider) you'll find there is enough light to photograph in many indoor situations. However, since the light is seldom extremely bright indoors, exposures may be relatively long. If you want to hand hold your camera, make sure that your shutter speed is fast enough to prevent camera motion blurring the image; you will need a shutter speed of at least 1/60 sec with a 50mm lens, even faster with longer lenses. A moving subject can also blur if the shutter speed is long (see pp. 70–73).

If light in a room comes mainly from a single source, such as a window or a single lamp, the light will illuminate objects near it but then fade off quickly (opposite, top). If a room has many sources of light, however, illumination will be more even and uniform (opposite, bottom). Before you make a picture, stop for a moment to look at the existing light. You may want to add to or rearrange the lighting or reposition yourself or the subject relative to the light.

Light that comes from above the subject, such as from overhead fluorescent fixtures, is often found in offices, schools, stores and other public places. It is not always an attractive light for people because it tends to illuminate the top of the nose brightly, while casting shadows into the eyesockets. However, it does create a realistic, on-site lighting, and since there is usually more than one light fixture in the room, shadows are relatively open and light.

Fredrik D. Bodin

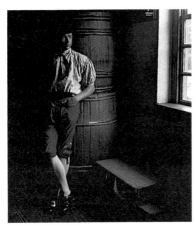

Robert Lee II

Light from a single source, such as a window or lamp, will fade off quickly into relative darkness. Above, it illuminated the man and the objects in the room only where they were close to and facing the window. If most of the image background is much darker than the main subject, automatic exposure will tend to overexpose the scene and make the picture too light. Here, the photographer set the exposure manually after moving in close to meter mostly the lit side of the man. He also could have used exposure compensation to decrease the exposure about 1 stop (see pp. 12–15).

Light will be softer and more even in a room with several light fixtures or windows illuminating the subject from different angles. Since the light was relatively uniform over the scene below, the photographer could have shot from several different angles and still had the subject well illuminated.

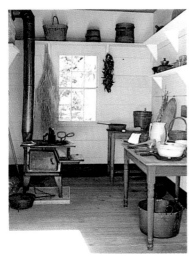

Robert Lee II

Light You Bring In

When there is not enough light to photograph indoors, it is easy to add light to the scene. Even if the existing light level is fairly high, you may want to increase the brightness of the illumination so that you can use a faster shutter speed to freeze the motion of a moving subject or a smaller aperture to increase the depth of field.

 You might also want to bring light in so you can control or vary the light better. Instead of being limited to the light available in the room, you can experiment with placing the light in different positions, diffusing it, and so on (see pp. 54–55).

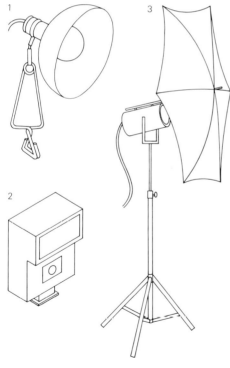

1 A 500-watt tungsten photo-flood bulb in a simple reflec-tor is an inexpensive way to bring light into a room. These units are available in camera stores where you can also buy a light stand to hold the reflector or a clamp to attach the reflector to a shelf, chair, or other object. Clear bulbs produce a good color balance with tungsten (indoor) color film; blue bulbs are available for use with daylight color film, but these do not put out as bright a light as the clear bulbs.

2 An electronic flash unit puts out a brief, bright burst of light. The units are compact; most attach directly to the camera. Electronic flash light produces good color balance with daylight color film. More about flash in Chapter 3 (pp. 36–47).

3 An umbrella reflector is used to bounce light onto the subject; the light (either a photoflood or flash) is pointed into the reflector, which then reflects it onto the subject. This provides a broader and more diffused light than lighting the sub-ject directly.

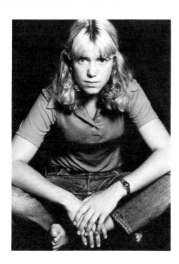 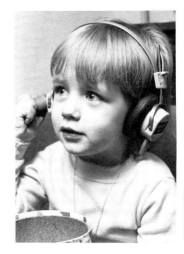

Fredrik D. Bodin

Above left: a light positioned above the subject and to the right of the camera was used for this portrait. The direct, rather hard light creates sharp shadows by the nose and lips and seems to intensify the mood of the woman's stare. Above right: the photographer added light to the light existing in this room so that he could have a shutter speed fast enough to hand-hold the camera and also prevent subject motion. He pointed a light into an umbrella reflector positioned to the left of the camera and slightly above the subject. Below: for a close-up of a sprouted onion, the photographer used one light placed above the subject to the right of the camera. He took many pictures of the same subject with the light in different positions, then chose this one as the best.

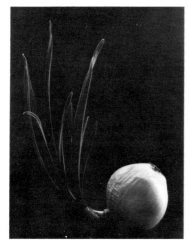

Sam Laundon

Candlelit and Firelit Scenes

Candlelit or firelit scenes are easy to photograph and can create unusual and interesting effects. These light sources are very warm in color, producing a red-orange cast that is flattering to skin tones and that adds to the mood of the picture. Tungsten-balanced film or a film with a tolerance for different color balances (such as Kodacolor 400) gives good results. A high film speed helps keep exposures reasonably short. Some films can be specially processed to 2 or more times their normal film speed; check manufacturer's instructions.

Candlelit or firelit scenes can confuse your camera's automatic exposure system. A bright light source (such as fire flames) included in the picture may cause underexposure and pictures that are too dark; on the other hand, a very large, dark background (often found in such scenes) may cause overexposure and too-light pictures. Try an exposure or two on automatic, if you wish, or set shutter speed and aperture manually (see chart below). In either case, bracket your exposures so that in addition to the basic exposure, you take at least one additional picture with 1 stop more exposure, plus one picture with 1 stop less exposure.

Shutter speeds are slow at this dim light level, so use a tripod and try to have your subject keep still. Position the subject so that the lit side of the face is visible from camera position (unless you want the subject silhouetted against the light).

Candlelight/Firelight:
Suggested Exposure for Manually Set Shutter Speed and Aperture

	ASA or ISO 100 (DIN 21)	ASA or ISO 200 (DIN 24)	ASA or ISO 400 (DIN 27)
Candlelit close-ups	1/4 sec, f/2	1/8 sec, f/2	1/15 sec, f/2
Firelit subjects	1/8 sec, f/2	1/15 sec, f/2	1/30 sec, f/2

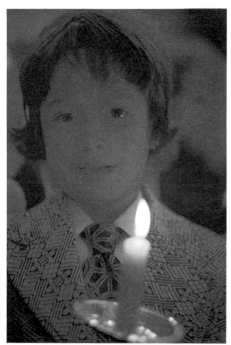

Donald Dietz

The reddish tones of candlelight or firelight cast a warm glow that seems natural for the source of light. You may want to bracket the automatic exposure with additional shots or set the exposure manually (see opposite).

Sam Laundon

Fill Light

Light on a subject indoors can be quite contrasty, with the lit side of your subject much lighter than the shadow side. This is particularly true if the light is coming from a single source like a window or a lamp. You can, if you wish, add fill light to the shaded side of your subject to lessen the difference in brightness (or contrast) between the lit and shaded sides. This difference will be much more noticeable in the final photograph (especially if you are using color slide film) than it is when you view the scene yourself.

The easiest way to add fill light is to use a reflector to bounce light from the main light back onto the shaded side of the subject (see opposite). You can also use a second light source, such as a tungsten lamp, as a fill light. Keep the fill light dimmer than the main light so it doesn't overpower it, and close to the camera so it doesn't create a second set of visible shadows. To avoid a mixture of colors in a color photograph, use clear tungsten bulbs to fill a scene illuminated with tungsten light; use blue-coated tungsten bulbs (available in photo stores) to fill a daylight scene.

Dark shadows don't have to be eliminated. You can use them as part of your picture (see below).

If the light on your subject is contrasty, with bright areas much lighter than shadows, you can simply accept that the shadows will be quite dark and use them as a part of your picture (right). Or if you want to lighten the shadows and make them less prominent, you can do so by adding fill light (opposite).

Rachel Rosenoff

If the shadows in a portrait or other indoor photograph appear much darker than the lit side of the subject (above left), you can lighten them by using a light-colored reflector such as white cloth or cardboard or crumpled aluminum foil (below). Place the reflector so it faces the main light, then adjust its angle until you can see some lightening of shadows (above right).

3 Flash

Fredrik D. Bodin

Automatic Electronic Flash

Modern automatic flash units are compact and lightweight, a good match for today's compact automatic cameras. You set the camera's shutter to the correct speed to synchronize with flash—some units even do this for you—and the lens aperture to the correct f-stop for the particular film speed you are using. The flash unit reads the light reflected back from the subject and automatically terminates the flash when the exposure is correct. A medium-sized flash unit will automatically supply the correct amount of light for a subject within about a 1–8 m (3–25 ft) distance range.

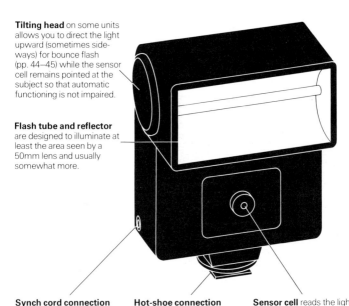

Tilting head on some units allows you to direct the light upward (sometimes sideways) for bounce flash (pp. 44–45) while the sensor cell remains pointed at the subject so that automatic functioning is not impaired.

Flash tube and reflector are designed to illuminate at least the area seen by a 50mm lens and usually somewhat more.

Synch cord connection allows use of a synch cord to provide an electrical connection so that the flash can be used at a distance from the camera. Not provided on all models.

Hot-shoe connection attaches to the hot-shoe flash bracket on the top of the camera. Supports the flash on top of the camera and provides electrical connection between the two.

Sensor cell reads the light reflected back from the subject during the exposure. Connected to circuitry that terminates the flash when the exposure is adequate.

A dedicated or designated flash unit provides extra functions when used with certain cameras. It sets the shutter to the correct speed to synchronize with flash and lights up a signal in the viewfinder when the flash is charged and ready to fire.

Calculator dial shows the lens aperture to use with various film speeds: in manual operation for subjects at specific distances from the lens; in automatic operation for subjects within a range of distances.

Battery compartment contains the flash unit's power supply. Alkaline batteries must be replaced periodically. Some units can be used with nickel-cadmium batteries, which are rechargeable. Thyristor circuitry in some models conserves energy and shortens recycling time between flashes.

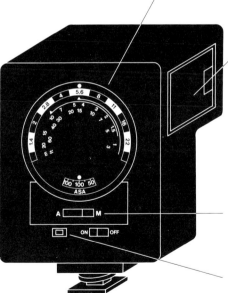

Mode selector on some units offers choice between automatic or manual operation and in automatic may offer a choice of distance ranges.

Ready light signals when the flash is charged and ready to fire.

Flash Characteristics

Because the burst of light from a flash is so brief, you can't see the exact effect that flash illumination has on your subject at the time you make a picture. However, flash does have certain basic characteristics and once you become familiar with them you will have a better idea of how to position and use the flash.

David M. Stone

Flash light falls off (becomes dimmer) the farther it travels. You can't see this when the flash goes off—but you will when you get your pictures back. Objects near the flash will be lighter in a picture than objects farther away. You can use this to advantage; for example, at night you can isolate a subject against a dark background (above). However, this characteristic creates a problem if you want to illuminate a scene that includes objects at varying distances from the flash (below, left). The best solution, unless you bring in extra lighting, is usually to group objects so that they are all approximately at the same distance (below, right).

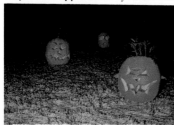 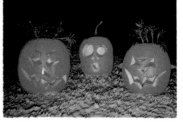

Jerry Howard

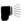

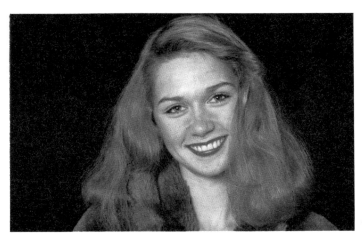

Jon Cooper

Flash on camera, such as a flash unit attached to the camera's hot shoe, is convenient to use: everyplace you and the camera move the flash moves with you. All flash-on-camera lighting looks very much the same—a flat, relatively shadowless light that minimizes surface textures and volumes. There is nothing wrong with this type of lighting; in fact, people who are concerned about their facial wrinkles will like the way it seems to make their skin look smoother. However, you can position the flash in other ways to produce a more rounded and textured effect, which often looks more attractive (see pp. 44–45).

Flash stops motion. Although the camera shutter speed used with flash is only 1/60 sec (1/125 sec at the fastest), the flash of light itself is so fast that it will easily record almost any moving subject completely sharp. Moving children, athletes, machinery, or any subject in motion that you want to see sharp will be easy to photograph with flash as long as it is within the distance that the flash illuminates and all important parts of the scene are at more or less the same distance from the flash (see opposite, bottom).

Jerry Howard

Flash Exposures

AUTOMATIC

Using an automatic flash is easy. Once the camera and flash controls are set, all you have to do is make sure the subject stays within the range of distances suitable for your unit. The flash's automatic sensor cuts off the flash when exposure is correct.

A dedicated flash will automatically set your camera to the correct shutter speed (if your flash isn't dedicated, see your owner's manual for the correct shutter speed). You then set the lens aperture depending on the power of your unit and the film speed you are using. Some units work on automatic at only one aperture with any given film speed. Other flash units offer automatic operation at a range of working apertures. With these, you set the lens to one aperture, perhaps f/2.8 for distant subjects, then to a smaller aperture like f/5.6 for those that are nearby. On cameras where the flash is measured off the film plane by the through-the-lens metering system, all apertures can be used successfully. Usually, the more powerful a unit is, the greater the range of distances at which it works automatically and the more choices you have in aperture settings.

How the Auto Sensor Works

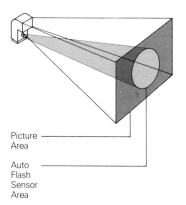

Picture
Area

Auto
Flash
Sensor
Area

The sensing cell that controls automatic flash operation reads only a portion of the scene you are photographing. If your main subject is at the very edge of the flash's illumination, it may not be metered properly. When possible, try to have the subject more or less in the central portion of the scene.

MANUAL

When set on manual, your flash's automatic circuitry is discon-
nected and the flash no longer automatically terminates when
sufficient light has been emitted. Exposure is controlled by setting
the aperture according to the distance between your subject and
the flash. To determine exposure in manual operation with the flash
calculator dial:

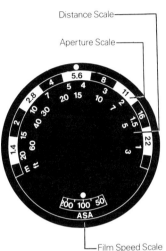

Distance Scale

Aperture Scale

1. Enter the film speed into the
flash unit's film speed dial.
Set the camera's shutter to the
correct speed for flash.

2. Focus the camera on the
subject and read its distance on
the lens's distance scale.

3. Find the aperture recom-
mended (on the flash unit's cal-
culator dial) for that distance.
When in a very large room,
you may need to open the lens
aperture 1 stop wider than
the recommended setting.

Film Speed Scale

*These costumed merrymakers were photographed with automatic flash. If
the subject occupies the center of the photograph, as here, an automatic
flash sensor is more likely to give an accurate reading than if the subject is
very much off to one side.*

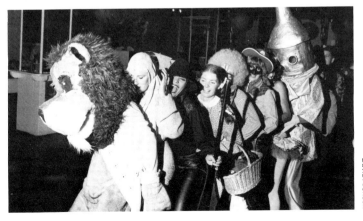

David Aronson

Bounce Flash

Flash light bounced onto a subject from a wall, ceiling, umbrella reflector, or other reflective surface gives a softer, more diffused light than direct flash, and is often more attractive for portraits (opposite). To bounce light from a flash, you need either a flash with a head that swivels, like the flash shown on p. 38, or a flash that can be electrically connected to the camera with a synchronization (synch) cord so that the flash can be pointed in one direction while the camera is aimed in another. You also need a reflecting surface that isn't too far away; by the time your light bounces off the ceiling of the Astrodome, for instance, or even a school gym, it will be too weak to be usable.

If your flash unit's sensor cell remains pointed at the subject when the head is tilted, you can leave the flash on automatic and get a correct exposure. Otherwise, set the flash for manual operation. Estimate the distance that the light travels from flash to reflecting surface to subject and use the flash unit's calculator dial to find the correct lens aperture, but set the aperture 1 or 2 stops wider than the recommended one to allow for light absorbed by the reflecting surface. Umbrella reflectors, especially shiny silver-toned ones, are more efficient reflectors than a wall or ceiling. See the manufacturer's suggestions for positioning the flash and calculating the correct exposure.

Three ways to bounce flash. Left: flash unit with tilting head on camera. Center and right: flash off camera connected by synch cord, bounced from wall (center), bounced from umbrella reflector (right).

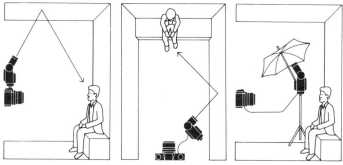

Flash positioned on or near the camera and pointed directly at the subject produces thin and sharp-edged shadows that tend to flatten out volumes and surface texture.

Flash bounced from the ceiling creates a more natural-looking light than does direct light (above). Shadows are softer and not so dark because the light comes from a broader area and tends to wrap around the subject. Volumes appear rounded rather than flattened.

Flash bounced from a wall also gives a soft, even light. It is often more flattering than ceiling bounce because it does not create dark shadows in eye sockets.

An umbrella reflector is a versatile accessory for bounce light arrangements because the umbrella can be moved easily to any position. Here the umbrella was above and to the left of the camera.

Susan Lapides

Common Flash Problems

Most of the problems that occur with flash are not difficult to cure. Problems occur because the light from the flash is so brief that you don't have a chance to see the effect of the flash on your subject. In fact, ''Did it fire?'' is sometimes asked by photographers because the mirror inside a single-lens reflex camera blocks out the image just as the flash goes off. Some common flash problems are shown below. See also flash falloff, illustrated on p. 40.

Visible reflections from shiny backgrounds like windows, mirrors, or smooth-surfaced walls are caused by pointing the flash and camera straight at the reflecting surface (left). Stand at an angle to a reflective background so the light will bounce away from the camera instead of back into the lens (right).

Reflections can also appear in a person's eyeglasses. If you get reflections from the blood-rich retina of the eye, the eyes may appear red or amber in a color photograph, the so-called redeye effect. Both of these problems are likely to occur with flash-on-camera lighting when the subject is looking directly at the camera. Prevent this problem by using bounce flash or by having the subject look slightly away from the flash.

David Aronson

A partially exposed picture occurs if the flash fires when the shutter is only partly open, and this is almost always because the shutter was set at too fast a speed. Many cameras must be set to 1/60 sec or slower shutter speed; some can be used up to 1/125 sec. See your camera's instructions for the correct flash setting.

A picture that is dark at the edges is caused by using the flash with a lens on the camera that is too wide-angle; the lens sees more of the scene than the flash is able to illuminate. All flash units cover the area seen by a 50mm (or longer) lens; most cover the area seen by a 35mm lens. Some have accessory wide-angle diffusers that spread the light over an even wider area. Check your flash manufacturer's specifications.

Flint Born

4 People

Jerry Howard

Portrait Basics: Get Close

Pictures of family and friends are one of the most popular types of photographs. Yet, so often the photographs are only record shots, showing something about what the people looked like, but conveying little about their personality and lacking the visual excitement and interest that portraits can have. This chapter gives some easy-to-use ideas for making better pictures of people. (See also Chapters 2 and 3, pp. 20–47, on lighting.)

Fill the picture's frame with your subject. Beginning photographers usually tend to hold a camera horizontally (right), but pictures of people often fit better in a vertical format (below left). You may also want to try moving close enough so that your subject's face occupies a larger part of the picture (below right and opposite).

Ken Robert Buck

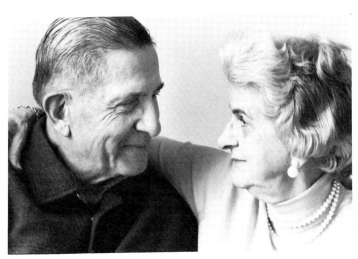

Get close to your subject. The most important part of most portraits is the face and its expression. Get close enough so that you can see them clearly (above). To get a large image you can shoot close to your subject or you can shoot from farther away using a long-focal-length lens. Working at very close distances may cause distortion (see below), but this is much less likely to be a problem than working from too far away.

Photographing extremely close to someone may distort the appearance of the face, causing those features that are closest to the camera, such as the nose, to appear unnaturally large (left). A medium-long 85–135mm lens is a good portrait lens; it gives a head-and-shoulders portrait from far enough back to prevent distortion (right), about 2–2.5 m (6–8 ft).

Cynthia Benjamins

Willard Traub

Portrait Basics: Backgrounds

It's easy when making a portrait to concentrate so much on expression and pose that you forget to look at the background against which the subject will be seen. But in the final photograph the background will be harder to ignore. You can emphasize a background by focusing it sharply (pp. 56–57 tell how to do this). You can minimize a distracting background and make it less conspicuous by having it out of focus (this page, bottom) or angling so that it is not in the picture (opposite, bottom). The only thing you don't want to do is to discover after you get your pictures back that the background could have been improved (below).

Right: a jumble of unimportant objects in the background distracts the eye from the main subject. Sometimes you can simply move around the subject to shoot at a better angle. Below: using a wide lens aperture made the background out of focus and less distracting than if it had been sharp.

William E. Smith

Donald Dietz

Above: a potted plant and sunlight on a wall make an unobtrusive but engaging complement to this portrait. Below: angling up or down on a subject can remove extraneous elements from the picture. Here it also adds to the upward movement of the dancer's gesture (left) and reinforces the child-size of the subject (right).

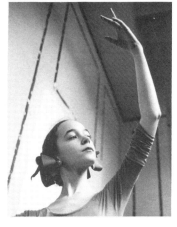

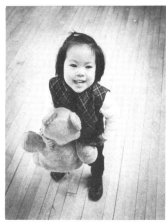

54

A One-Light Portrait

Just one light is enough to make a portrait, but where you position that light can make a face look narrow or broad, smooth or lined, appealing or menacing. All the pictures here were made with a single 500-watt bulb in a simple reflector. You could also use a flash unit if the unit can be connected for off-camera use. Existing room light can create similar effects.

Near the lens. *With the light as close as possible to the camera, the face appears rather flattened and textures, including lines on the face, are minimized.*

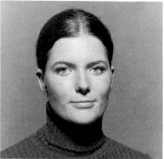

High front. *Raising the light about 45° above the lens casts shadows by eyes, cheekbones, and lips and gives volume to the face.*

High 45°. *Placing the light about 45° to one side and 45° up is an attractive lighting for most faces. Often used in commercial portrait studios.*

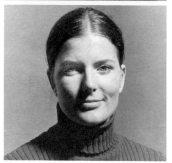

Side. *Placing the light about 90°
to one side lights the subject
brightly on one side and puts the
other side in shadow. Tends to
dramatize the subject.*

Top. *With the light directly over-
head, dark shadows are cast
into eyesockets and under nose
and chin. Occasionally used
for very stylized portraits.*

Bottom. *Light from below looks
oddly unreal because it occurs so
seldom in nature. The effect can
vary from space age to Franken-
stein's monster.*

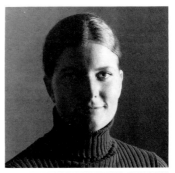

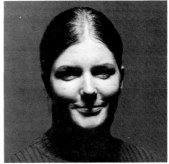

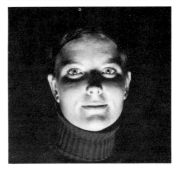

Sam Laundon

Environmental Portraits

Showing how people relate to their environment, at work or wherever they live their lives, often tells more about them than a simple head-and-shoulders portrait.

If you want both your subject and the surrounding area to be sharp, you will need as much depth of field as possible. Depth of field is the area in a photograph that appears acceptably sharp. It includes the point that is most sharply focused (below: the face of the Hong Kong rice merchant) plus some objects towards the camera (the containers of grain in the foreground) and some objects away from the camera (the grain behind the merchant). Three ways to increase the depth of field are shown at bottom.

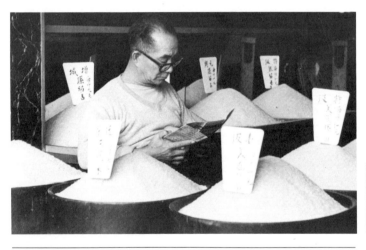

Barbara M. Marshall

**Depth of field
increases if you**

 Use a
smaller lens
aperture

 Use a
shorter focal
length lens

 Move further
back from
the scene

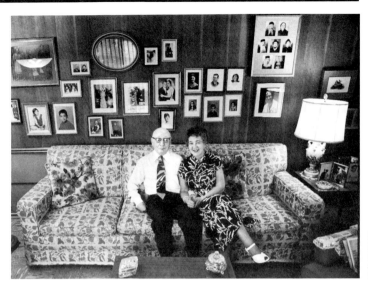

Barbara Alper

Environmental portraits reveal something about your subjects by showing something of their surroundings. Above: a photograph about photography and the part that it plays in one couple's life. Below left: a woman at work; the rock samples in the boxes echo the neat sorting of the periodic chart of the elements on the wall. Below right: hanging out at a boxing club; the boxing gloves and picture on the wall are symbols of what the boy could become.

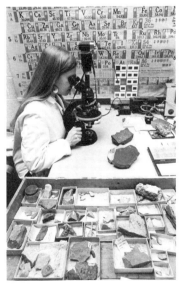

Fredrik D. Bodin

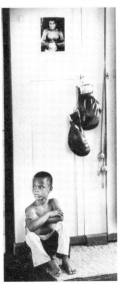

Fredrik D. Bodin

Photographing Children

Children have a notoriously short attention span, so make as many camera adjustments as you can before moving in to take a picture. Set the film speed, load and advance the film or make sure you have enough frames left in the camera, and decide whether automatic exposure will work well or exposure compensation is needed. Become familiar enough with your equipment so that focusing or any other last-minute adjustments will consume a minimum of time. A fast film and/or bright light will let you use the fast shutter speeds (1/125 sec or faster) that capture action while it is happening.

Soft, diffused light gently models this photograph of a sleeping baby. The photographer used a medium-long lens so that he could fill the frame with the baby's head without having to get so close that the features would be distorted. (See p. 51.)

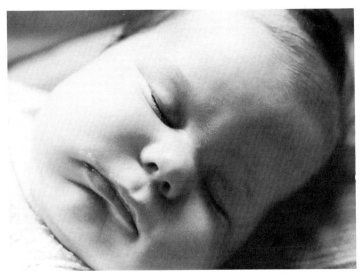

Fredrik D. Bodin

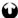

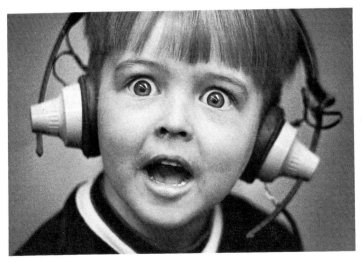

Greg Schneider, *San Bernardino* (Cal.) *Sun*

Children who have something to do will behave much more naturally than they will if you tell them to smile while you take their picture. Above: listening to music through earphones. Even adults look surprised the first time they experience the inside-the-head effect produced by stereo earphones. Below: children engrossed in playing music and playing photographer.

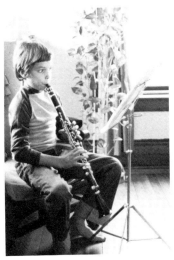

Cynthia Benjamins

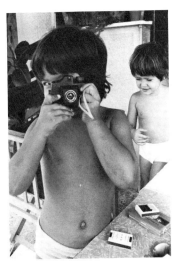

Hillary Liss

Portraits with a Theme

You can add interest to your photographs about people by collecting and showing those on a related topic. Children and food are just one of the many themes that you can choose. What do you enjoy photographing? Circus performers? People at the zoo? Holiday activities? You can collect photographs of a single person or of many. A theme will unify the pictures and give them more appeal for your viewers.

Food has a universal appeal. Food occupies the attention of people who are involved with it so that you can take candid pictures of them; people who look at your photograph are likely to respond to the subject as well.

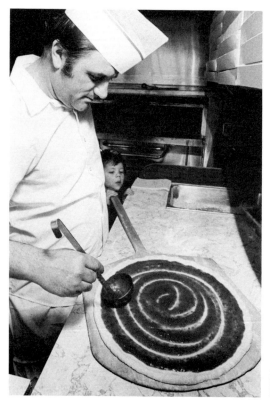

David A. Krathwohl

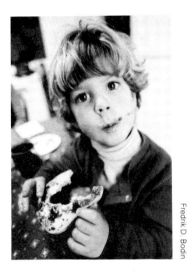

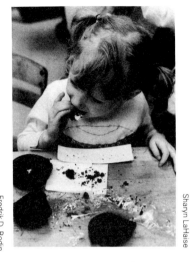

Fredrik D. Bodin

Sharyn LaHaise

Food—and how children deal with it. Above left: the inevitability of jelly all over everything. Above right: the brave attempt to keep the cupcake crumbs on two small pieces of paper. Below left: mouth gets ready to meet spoon, maybe. Below right: boy meets pickle.

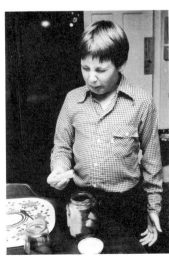

Elizabeth Hamlin

Margaret Thompson

Pets Are People, Too

If you think children have a short attention span, try photographing animals. Only an extremely well-trained dog will "Hold it" while you make last-minute camera adjustments, so get as much set beforehand as you can. As with children, a fast shutter speed (1/125 sec or faster) is essential.

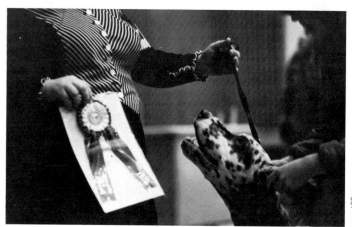

Peggy Cole

Above: first prize at the dog show. Below: a snapping turtle's favorite treat—vanilla ice cream. In both cases, the viewer concentrates on the animals because human faces are not visible. The backgrounds are out of focus because a wide lens aperture was used.

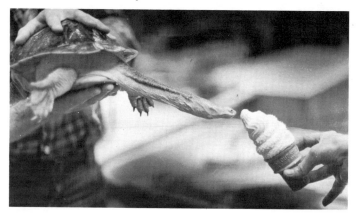

Bruce Gilbert, *Miami Herald*

Barbara Alper

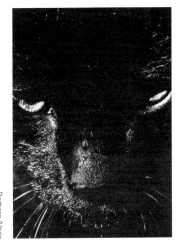

Fredrik D. Bodin

Above left: if that is a real lamb chop, the dog is showing an extraordinary amount of self control. Above right: the photographer decreased the exposure 2 stops from the recommended automatic exposure so that only the bright highlights on fur, whiskers, and eyes stand out against the dark fur. (See pp. 12–15 for when and how to override your automatic camera.) Below left: some animals don't object to human direction of their behavior. Below right: some animals do.

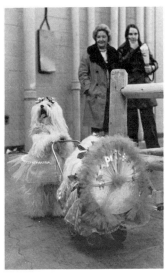

Donald Dietz

Barbara M. Marshall

64

Unconventional Portraits

Portraits are as varied as the people who are in them and the people who make them. You don't have to show the whole face (below) or even the person at all (bottom). You can experiment with filters or screens (opposite top) and with different types of film (opposite bottom). A portrait could extend into a photo story; see Chapter 7 (pp. 108–121).

Right: a pair of people making one pair of eyes. Below: it isn't clear whether this room is still lived in or whether it is preserved for a daughter who has grown up and moved away. The presence of the person fills the room and the photograph, even though she isn't there herself.

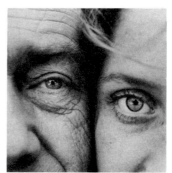

Margaret Thompson

Rachel Rosenoff

An ordinary screen door between the subject and the camera adds texture to this photograph. Various special effects filters that attach to the front of the lens can make a portrait soft and hazy (soft-focus filter), make it a multiple image (prism filter), put starry rays around bright lights (star or cross-screen filter), and so on.

Jean Shapiro

Below: for a grainy, softened portrait with unusual skin tones, try black-and-white infrared film. This film responds to infrared wavelengths that are invisible to the human eye and that do not behave in exactly the same way as visible light. Some changes are needed in the way film and camera are handled. Load and unload the film in total darkness; ordinary dim light is often enough to fog the film. Infrared light focuses at a slightly different point than visible light; a lens barrel has a red dot or other mark to indicate how much the focus should be changed. Bracket exposures as much as 2 stops on either side of the regular exposure, because metering cells can only estimate an infrared exposure. A red # 25 filter over the lens absorbs the blue light to which the film is also sensitive. Infrared color film is also available.

Luther Smith

5 Sports and Recreation

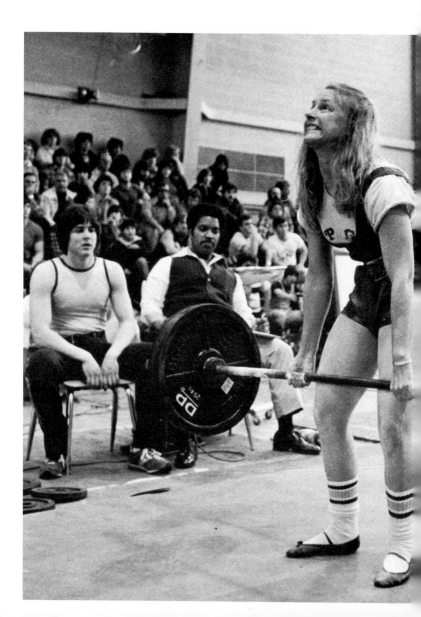

Ken Robert Buck

Basics of Indoor Sports Photography

Exciting pictures happen indoors at sporting events—or wherever people are having fun. In many of those pictures people are *moving,* so whether you want to photograph a wrestler or a ballet dancer flying through the air, you'll need to know something about how the camera records motion (see pp. 70–73) and how to focus for action pictures (see pp. 74–75). Some basic equipment that you'll find useful is described opposite.

If you can get close enough to the action you can photograph a moving subject sharply by using flash. The burst of light from electronic flash is so brief—1/1000 sec or less—that it stops virtually any motion. It also eliminates distracting background elements by isolating the illuminated subject against black. However, the light from a medium-sized flash will be useful only up to about 8 m (25 ft) from a subject. Beyond that distance the light will not be bright enough to be of much benefit. Below, the photographer was at ringside, close enough to use flash. (See pp. 36–47 for more about flash.)

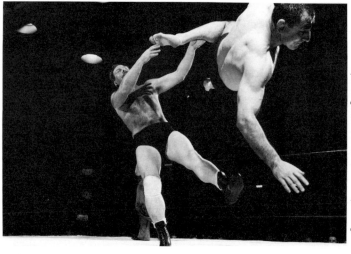

EQUIPMENT FOR INDOOR SPORTS PHOTOGRAPHY

Fast film, ASA or ISO 400 (DIN 27) or higher, requires less exposure than slower films (those with lower film speed ratings). Light indoors is almost always dimmer than in outdoor daylight locations, so a fast film is particularly useful when you want to shoot at the fast shutter speeds needed to stop motion. Certain films can be ''pushed,'' given special processing so that you can expose them at higher film speeds. For example, Kodak Ektachrome 160, normally rated at ASA 160, can be exposed at a film speed of 320 if specially processed. See manufacturer's instructions. The graininess and contrast of the image increases and colors may not be as bright and true, but the increase in film speed is often worth some loss in image quality.

A fast lens, one that opens to a wider-than-normal maximum aperture is also an advantage in low light levels, particularly if you want to use long-focal-length lenses because these open to relatively small maximum apertures. A typical 200mm lens, for example, opens only to about f/4; a fast 200mm lens will open to about f/2.8. The extra f-stop can come in handy when you need every bit of speed that you can get. The penalty here is in price and in increased bulk and weight.

A long lens magnifies objects, so it is useful for getting closer views of action from across the playing area. A medium-long lens, 85–200mm, will be adequate in most indoor situations, though you may want a longer lens (which magnifies more) if you are high in the stands. The longer the focal length, the less depth of field you have (the less of the scene that is acceptably sharp), particularly if you are working at a wide aperture, so focusing becomes critical. Longer lenses need a faster shutter speed if you want to hand hold them, at least as fast as the focal length of the lens—1/250 sec for a 200mm lens, 1/500 sec for a 400mm lens.

A zoom lens lets you shoot at a variety of focal lengths and is more convenient than carrying several different lenses.

A camera support is useful with a long lens because it prevents the blur caused by camera motion. A tripod is stable, but a bit bulky. A monopod, a single-leg support, is less steady but more mobile.

Electronic flash not only adds light to a scene but shows action sharply as well. If the flash unit recycles fast enough, it can even be used with a power winder for rapid sequence shooting. A medium-sized unit that attaches to the camera is convenient, but must be used relatively close to the subject (see opposite bottom).

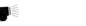

Photographing Motion

If you do want to show moving subjects sharply, you need to use either flash (see pp. 36–47) or a fast shutter speed. How fast a speed to use is a little hard to predict because the faster the motion or the closer you are to it or the longer your lens, the faster the speed must be. The direction that the subject is moving relative to the camera also affects the shutter speed you need (see opposite). As an estimate, 1/250 sec shows most motion sharply. You may need 1/500 sec with a fast-moving sport, if you move up close or if you switch to a longer lens. If the light isn't bright enough to shoot at such a fast speed, you have several options: switch to a faster film speed or "push" the film you are using (see p. 69), use flash or take a chance on a slower shutter speed.

A fast shutter speed stopped the action in this shot of basketball players scrambling for a loose ball. In a fast-paced game like basketball, a shutter speed of 1/500 sec is often needed to show moving subjects sharply.

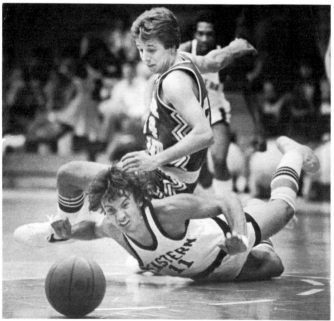

Harold Hanka, Willimantic (Conn.) Chronicle

Slow shutter speed, subject blurred. *The direction that a subject is moving relative to the camera affects the shutter speed needed to record motion sharply. At a slow shutter speed, a subject moving from left to right is blurred.*

1/30 sec

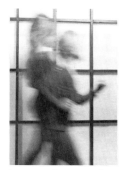

Fast shutter speed, subject sharp. *At a fast shutter speed, a similar subject moving in the same direction is sharp because the image did not have time to cross enough of the film to blur.*

1/125 sec

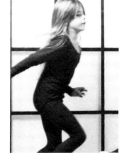

Slow shutter speed, subject sharp. *Even though the shutter speed was slow, the subject is sharp because the motion was directly towards the camera; the image did not cross enough of the film to blur. The same effect occurs with subjects moving directly away from the camera. Motion at an angle to the camera would require a somewhat faster speed.*

1/30 sec

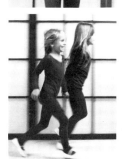

Panning the camera, *moving it in the same direction as a moving subject, will keep the subject relatively sharp while the stationary background will be blurred.*

1/30 sec

Larry Lorusso

More About Motion

Moving subjects don't have to be photographed so they appear dead sharp, frozen in mid-motion. Sometimes a blurred image conveys more of a sense of motion than a sharp one (opposite bottom). If you have the opportunity, make several shots at different shutter speeds. When you see the final photographs, you can choose the ones you like best. Make a note of the shutter speeds you use; this will help you choose a suitable shutter setting in similar situations.

To keep the exposure the same, the lens must be opened wider each time the shutter speed gets faster. Changing shutter speed in shutter-priority operation is easy; as you increase the shutter speed, the camera automatically opens to a correspondingly wider lens opening. Make sure you don't increase the shutter speed so much that you underexpose the film because the lens will not open up any wider. With an aperture-priority camera, you increase the shutter speed indirectly by opening the lens wider; the camera automatically sets the shutter faster.

Action slows just before it reverses direction: the peak of a jump, for example, or just as a player dunks the ball into a basket (below). Slower shutter speeds will show the action sharply at this peak of action. The photograph below is also notable for its unusual point of view—looking straight down from the rafters of a gymnasium.

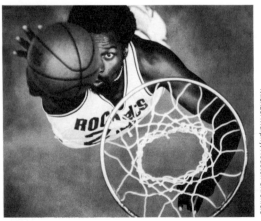

Michael Murphy, *Houston Chronicle*

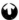

Right: table tennis, especially championship play, is extremely fast moving. The slight delay between deciding to snap the shutter and the actual movement of your finger can be long enough for the shot that you want to have passed. Try to anticipate the action and release the shutter slightly beforehand. A power winder can be useful in a situation like this since it can reel off several shots in a row. Below: a slow shutter speed, 1/8 sec, blurred the motion of folk dancers. Notice that the dancers closest to the camera who are moving from one side to the other blurred more than the others. Page 71 tells why.

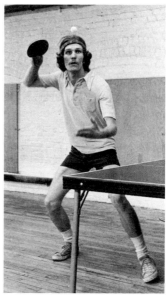

Bohdan Hrynewvych

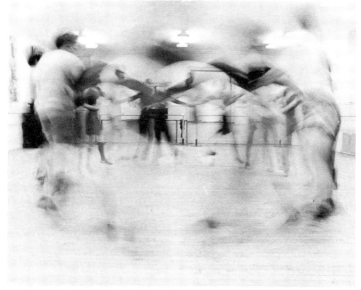

Bohdan Hrynewvych

Focusing for Action

The quicker you respond to an action situation, the more likely you are to get the picture you want. If you know approximately where action will take place, you can prefocus your lens so that when something interesting happens all you have to do is raise the camera to your eye and shoot. Zone focusing uses the depth-of-field scale on your lens barrel to preset your depth of field, the area in a picture that is acceptably sharp (see below).

How to Zone Focus

Suppose you are photographing a tennis match and want one entire side of the court to be sharp. First, focus the nearest point you want sharp; read that distance off the len's distance scale (here, about 6.5 m or 20 ft from the camera). Then focus on the far- thest point (about 20 m or 60 ft).

Line up the distance scale on your lens so that the nearest and farthest distances are opposite a pair of f-stop indicators on the depth-of-field scale.

If your aperture is set to this f-stop (in this example, f/16) everything from 6.5 to 20 m (20 to 60 ft) will be within the depth of field and sharp in the final picture. (With a shutter-priority camera, try a series of shutter speeds until the desired aperture appears in the viewfinder readout.)

After setting the aperture, make sure your shutter speed is fast enough. You may have to settle for a wider aperture with less depth of field to get the shutter speed you want.

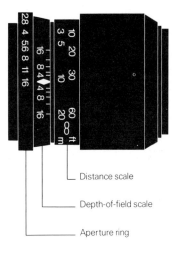

— Distance scale

— Depth-of-field scale

— Aperture ring

Below: you can make sure that anyplace on the court where this player moves will be sharp if you zone focus—preset your focus and lens aperture as explained opposite. Right: zone focusing on this aerial balancing act freed the photographer from last minute adjustments that might cause him to miss a good shot. In both of the scenes here, the subject is brightly lit against a large dark background, a situation that is likely to fool your camera into overexposing the main subject. See pp. 82–83 for how to prevent this.

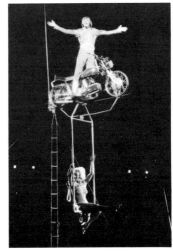

George Cannon

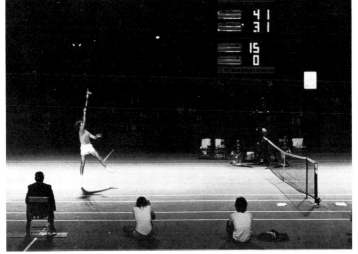

Barbara M. Marshall

Spectator Sports

The greatest flexibility in making sports photographs comes if you can shoot from the sidelines, but permission to do this is generally hard to get at major professional games. You may be able to get permission at smaller amateur or school events, however, and practice sessions may let you get even closer (see pp. 78–79).

Even if you have to make all your pictures of a sporting event from a seat in the stands, good shots are still possible, particularly if you have a long-focal-length lens to bring you closer to the action or a zoom lens to vary the shots.

If you can get close enough to shoot upward from a low angle, you can add even more height to an athlete's jump.

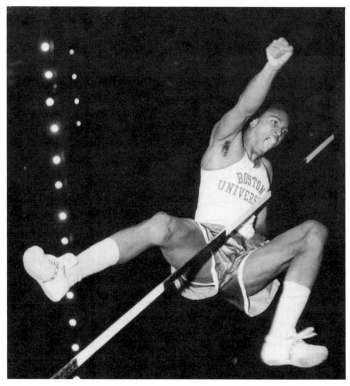

Don Robinson, UPI

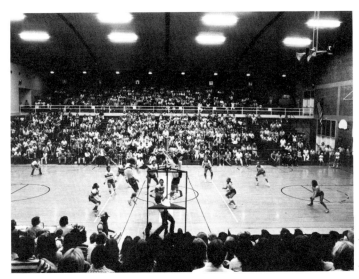

Terry McKoy

Above: a 50mm normal-focal-length lens from a seat in the stands will give you a good overall shot of most indoor sporting events, as in this volleyball game, but a long-focal-length lens, especially one used from the sidelines, brings you right into the middle of the action (below).

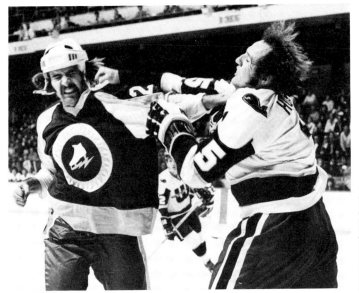

Frank O'Brien, *Boston Globe*

The People in Sports

The action in sports doesn't all take place on a playing field or even during a game. Sports are played by people, and a behind-the-scenes shot or one that reveals something of a player's personality can capture your viewer's attention too.

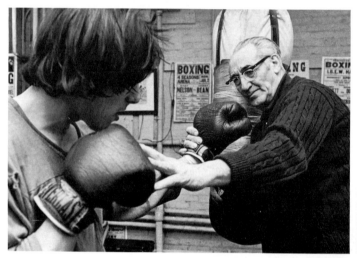

David A. Krathwohl

Above: a young boxer getting pointers. With the young man's face turned partly away from the camera, the viewer concentrates on the face of the coach. Right: an older boxer cooling down after a workout. The right glove of the younger boxer and the feet of the older one seem large because they were close to the camera.

Flint Born

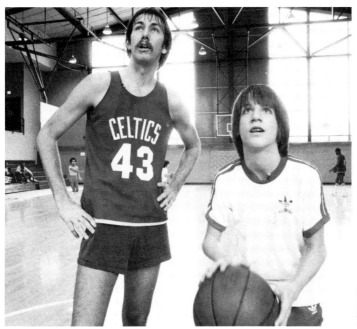

Jon Cooper

Above: another young player getting pointers from a pro. Below: a player-coach calls in a play change from the sidelines (left) and encourages his teammates (right). A long or medium-long focal-length lens is useful when you want an image big enough to see your subject's expression but you don't want to get in their way.

Michael Maher, *Lowell (Mass.) Sun*

Shooting from Another Angle

Most photographs are taken from the same position that most people view the world—from 5 or so feet above the ground and looking straight ahead. Often another angle can provide a new and unusual view, and in some cases can be the best way to see what is actually happening.

Right: what the pinball machine saw is more interesting than a view of the players' backs. Below: a ringside seat at an amateur wrestling match let the photographer shoot at mat level. Seeing the actual space between the mat and the referee's hand ready to descend to end the match gives immediacy to this shot.

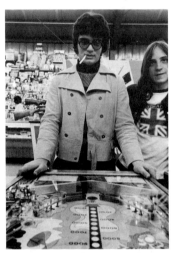

Donald Dietz

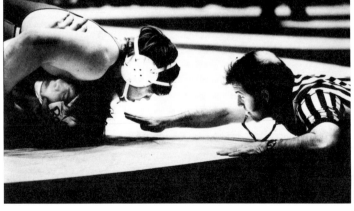

Flint Born

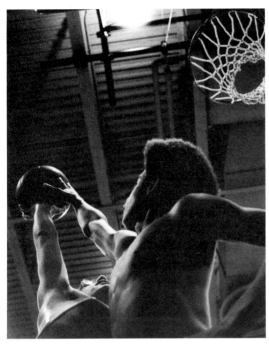

David A. Krathwohl

Above: shooting straight up from close to these players gives an unusual perspective on an ordinary practice session. See also p. 72 on shooting straight down. Below: the photographer placed his camera as close as he could to the mirror to get a double image of dancers in rehearsal.

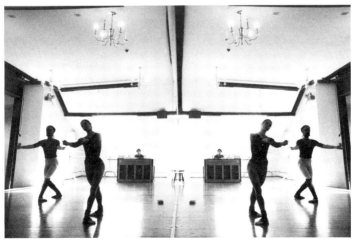

Stephen Muskie

Circuses and Ice Shows

These colorful and often spectacular events seem to invite picture taking. Automatic exposure works well when the house lights are up and the background as well as the main subject are illuminated (opposite, top) or for close-ups when the main subject fills most of the frame (opposite, bottom left). But if you want to photograph an act that is spotlit against a large dark background (opposite, bottom right), automatic exposure tends to overexpose the main subject and make it too light. In such situations, you can either set the exposure manually (see chart below) or, if you want to maintain automatic operation, decrease the exposure 1–2 stops through exposure compensation (see pp. 12–15). Don't plan on using flash except for close shots like the clown opposite; most units are not powerful enough to be used at a distance.

There will almost always be some variation in the color balance of your pictures. Not only are colored filters used on lights at different times during the show, but there are two different colors to the basic illumination: overall lighting generally comes from reddish tungsten lights (best rendered on tungsten film) while spotlighting of individual acts comes from bluish carbon arc lights (best on daylight film). Though you could place a filter over the film as the light changes or carry two cameras, each with a different type of film, an acceptable compromise is simply to use daylight film for all your shots. Colors under carbon arc lights will look natural while those under tungsten lights will shift somewhat to warm, orange-red tones. This is even less of a problem with prints (as opposed to slides) because the color balance can be adjusted during printing. Certain films like Kodacolor 400 are quite tolerant of shifts in the color balance.

Circuses and Ice Shows:
Suggested Exposures for Manually Set Shutter Speed and Aperture

	ASA or ISO 100 (DIN 21)	ASA or ISO 200 (DIN 24)	ASA or ISO 400 (DIN 27)
Circuses			
floodlighted scenes	1/30 sec, f/2	1/30 sec, f/2.8	1/60 sec, f/2.8
spotlighted acts	1/60 sec, f/2.8	1/125 sec, f/2.8	1/250 sec, f/2.8
Ice Shows			
floodlighted scenes	1/30 sec, f/2.8	1/60 sec, f/2.8	1/125 sec, f/2.8
spotlighted acts	1/60 sec, f/2.8	1/125 sec, f/2.8	1/250 sec, f/2.8

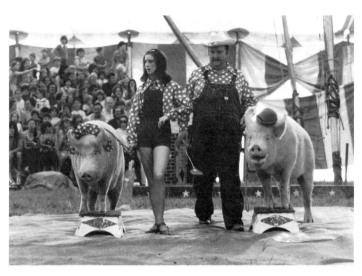

David A. Krathwohl

Use automatic exposure if a circus or ice-show scene is lit evenly overall (above) or if the main subject occupies most of the area visible in the camera's viewfinder (below left). But if you are shooting a relatively small, bright subject against a large, dark background (below right), you have to override the automatic system to prevent overexposure; either set the shutter speed and aperture manually (see chart opposite) or use exposure compensation to decrease the exposure 1–2 stops (see pp. 12–15).

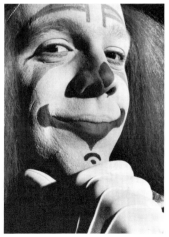

Ron Carraher

Barbara M. Marshall

Concerts and Stage Events

Getting a good exposure at a concert, play, or other event on stage is similar to getting a good exposure of a circus or ice show scene (see pp. 82–83). Automatic exposure works well if most of the area in your viewfinder is evenly illuminated (opposite, top left). However, if your subject is brightly lit against a dark background (opposite, top right), then automatic exposure tends to overexpose the subject and make it too light. You will get better results if you either set the exposure manually (see chart below) or use exposure compensation to decrease the exposure 1 or 2 stops (see pp. 12–15). Flash can be used for shots up close, but many theatres forbid the use of flash during a performance as a distraction to both audience and performers.

Scenes on stage are seldom static, and you will need a fast shutter speed to photograph moving subjects sharply. (See pp. 70–73 for more about photographing motion.)

David A. Krathwohl

Stage Events:
Suggested Exposures for Manually Set Shutter Speed and Aperture

	ASA or ISO 100 (DIN 21)	ASA or ISO 200 (DIN 24)	ASA or ISO 400 (DIN 27)
Average	1/30 sec, f/2	1/30 sec, f/2.8	1/60 sec, f/2.8
Bright	1/60 sec, f/2.8	1/60 sec, f/4	1/125 sec, f/4

Barbara Alper

Fredrik D. Bodin

Automatic exposure works well when both subject and background are evenly illuminated (above left). But if your subject is brightly lit against a large, dark background (above right), you should decrease the automatic exposure to prevent overexposure (see text opposite).

How to Find Equivalent Exposures

Suppose an exposure recommended in a chart like the one opposite is 1/60 sec at f/2.8, but you want to shoot at a smaller aperture, like f/5.6, to get more depth of field. How do you find the exposure that is equivalent to the one in the chart?

Shutter speed and aperture settings are each 1 stop apart. Setting your aperture to the next smaller opening halves the light reaching the film. (Remember that smaller apertures have larger f-numbers: f/4 lets in less light than f/2.8.) If you then change your shutter speed to the next slower setting, you double the light reaching the film, and the overall exposure will stay the same.

Look at the aperture ring on your lens and count the settings between the two apertures, in this example, 2 settings:
f/2.8 to f/4
 to f/5.6

Your exposure will stay the same if you change your shutter speed an equal number of settings:
1/60 sec to 1/30 sec
 to 1/15 sec

Museums and Galleries

Museums and galleries offer a surprisingly wide variety of subjects and shooting situations, from flat paintings to small objects under glass to reconstructed mastodons to complete spaceships. The first step is to check if picture taking is permitted. Some institutions prohibit photography by visitors altogether; more often, only flash units or tripods are forbidden.

Lighting is likely to come from mixed sources. If you are using color film, choose one to match the light that predominates. Use tungsten film if tungsten lamps are the principal source of light. Use daylight film in a museum lit by skylights and windows. Daylight film is also your best choice if fluorescent fixtures are present or if you use flash. See pp. 24–25 for information on the color of light indoors. A fast film will keep pictures sharp when you must hand hold the camera. Many of the specific situations you might encounter are covered elsewhere in this book; see especially Chapter 6, pp. 88–107.

The photographer symmetrically framed this statute of Buddha between two other statues and underneath an archway. Backgrounds are particularly important when you don't want to distract attention from the object you are photographing. If you can't use an existing background effectively, try making it out of focus by shooting at a large lens aperture (opposite top). (See also pp. 52–53.)

Susan Lapides

Jean Shapiro

Above: this partly shadowed side view of a statue with the highlight on the back of the head and neck was more interesting than the fully illuminated frontal view. Museums often light a statue or other three-dimensional object to bring out various aspects of its shape. Before you shoot take a look at the object from various sides.

Right: don't forget that people come to museums and their en-counters with objects on display can also be worth photographing.

John Littlewood

6 Close-ups and Still Lifes

Equipment for Close-ups

One of the fascinating aspects of making close-up photographs is that such common objects—a leaf, a flower, an ordinary vegetable—look so much more interesting when seen close up. To get a greatly enlarged image of an object on film, you need to use your camera closer than normal to the subject, but most lenses are not designed to let you work at very close focusing distances. The close-up equipment shown opposite either adapts your regular lens or replaces it so you can move in extremely close.

At close focusing distances even a slight change in camera position makes a big change in the image. The camera supports shown below help you compose a close-up picture exactly, and help keep the camera steady during longer-than-normal close-up exposures.

A copy stand can be used to keep the camera steady during a close-up exposure if you are photographing an item that can be laid on a table. The camera attaches to a movable arm that can be locked in position at any point on the supporting standard. An ordinary tripod is less convenient, but could be used instead.

Another type of copy stand has four adjustable legs and a ringlike top into which the camera fits. A cable release (shown here attached to the camera) releases the shutter when a plunger is pushed and prevents accidental jarring of the camera.

Supplementary close-up lenses *fit over your regular lens like filters. They come in various strengths called diopters, +1, +2, and so on. The greater the diopter the closer you can focus and the greater the magnification. Unlike other close-up equipment, these lenses do not require any increase in exposure.*

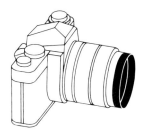

A macro lens *replaces your regular camera lens. Its lens mount can be extended farther than normal from the film so that without any other attachments you can focus closer than normal. It produces a sharp image at the very close focusing distances that often cause ordinary lenses to be less than sharp.*

Extension tubes, *which come in various lengths, fit between the camera and lens. The greater the length of the tube, the closer you can focus and the greater the magnification. An exposure increase is needed to compensate for the increased distance between lens and camera (see p. 94).*

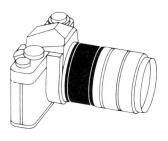

A bellows unit *also fits between camera and lens, but unlike fixed-length extension tubes, a bellows extends to varying lengths. An adapter ring is available for mounting a lens in reverse position. Even a macro lens performs better at extremely close distances when reversed.*

Depth of Field in a Close-up

The closer you focus on a scene, the less of that scene will be sharp in the final photograph. The depth of field—the distance between the nearest and farthest points that are acceptably sharp—may only be an inch or so at close focusing distances. Areas that are farther from or closer to the camera will be out of focus (see below).

If you want more depth of field you can shoot at a smaller aperture, but if you do so you may have to use a camera support to prevent camera motion since the exposure time lengthens as you decrease the size of the aperture.

Shallow depth of field can often be used to advantage. It can make a sharply focused subject stand out against an out-of-focus background. A sharp and detailed background that is not directly related to the subject can be a distraction and having it out of focus is one way to make it less prominent.

Depth of field is easily seen in the photograph at right. The nuts closest to the camera are definitely out of focus. They gradually become sharper as they approach the plane of critical focus—the point that was focused on. The

Depth-of-Field

Farthest sharp area →

Plane of critical focus →

Nearest sharp area →

nuts become out of focus again as they move farther from the camera. At close focusing distances, the depth of field extends about half way in front of and half way behind the plane of critical focus.

Barbara M. Marshall

Left: because depth of field is so shallow in a close-up, it is easy to make a distracting background less conspicuous by having it out of focus. Below: the photographer focused on the top of the onion. The bottom of the onion is far enough away to be out of focus. In close-up photography it is vital to focus carefully on the most important part of a scene.

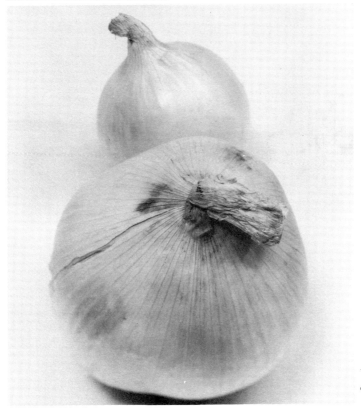

Eric Myrvaagnes

Close-up Exposures

Automatic exposure works well in close-ups of average scenes where the main subject is not too much lighter or too much darker than its background (see below). If the main subject is much lighter or darker, then you should use exposure compensation to adjust the camera settings (see opposite and pp. 12–15).

Extension tubes, bellows, and macro lenses make close focusing possible by increasing the distance between lens and film. But as this distance increases, the light that reaches the film decreases. The advantage of a camera that meters through the lens (as single-lens-reflex cameras do) is that the meter measures the brightness of the light that actually reaches the film.

If close-up accessories like extension tubes and bellows that come between the lens and camera are not specifically designed to integrate with the automatic system, they will interrupt the automatic functioning of the camera. If this happens the camera's meter will still work, but you will have to set the camera's aperture and/or shutter speed manually. See manufacturer's literature.

An automatic camera provides a good exposure of these pears in a bowl of water. The scene is of average tone with the background not too much darker than the main subject.

Jerry Howard

Sam Laundon

Above: a light colored orchid against a very dark background would have been overexposed and too light if the photographer had not decreased the exposure. Below: flowers against a very bright background would have been underexposed and too dark if the photographer had not increased the exposure. See pp. 12–15 for how to override automatic exposure when necessary.

For an accurate reading of an extremely small subject, you can make a substitution reading from a gray card, a card of middle gray manufactured for photographic purposes and available in camera stores. Place the card in the same light as the subject, meter the brightness of the card, and set the exposure manually.

Sam Laundon

Photographing Flat Objects

When copying old photographs or shooting any flat subject (like a postage stamp or drawing), you'll want to provide full, even illumination of the subject without reflections or distracting textures and shadows. The best source of illumination consists of two lamps of equal intensity, arranged as shown opposite. A copy stand like one of those shown on p. 90 makes the job easier but isn't essential.

Depth of field is very shallow at close focusing distances (see pp. 92–93); you'll need to align the back of the camera parallel to the object or the focus may not be evenly sharp overall. Keeping the camera parallel also prevents distortion of the object; if the camera is not parallel, the part of the subject that is closer to the camera will be bigger in the image. This is particularly evident in rectangular objects, which "keystone" or take on a wedge shape (see below).

If you are copying an old photograph or other black-and-white object onto a black-and-white film, you can sometimes improve the image by filtering to lighten stains. Use a filter the same color as the stain: a yellow filter for a yellowish stain, blue filter for a bluish stain, and so on. Use a slow to medium speed film; the contrast and rendition of detail will be better than with very fast films.

If the camera back is not aligned parallel to the object you are photographing, you may get uneven focus as well as "keystoning," an enlargement of the part of the object closest to the camera. In this copy of a painting, the camera was tilted up a little; the bottom of the painting was closer to the camera than the top and therefore was larger. A carpenter's (spirit) level can be placed on top of the camera to make sure the camera is level and not tilted.

Susan Lapides

O

For even illumination of a flat object, place two lights of equal brightness, one on each side of the object, at about a 45° angle to it. Two 500-watt photoflood bulbs in reflectors are efficient light sources. Don't place the lights too close to the camera or you are likely to get reflections off the surface of the object, especially if it is at all glossy. Nor should you place them at too shallow an angle to the surface or you may make texture or surface unevenness visible.

Below: a copy of a photograph taken around the turn of the century. Yellowish stains on the original were made less conspicuous by photographing through a yellow # 8 filter.

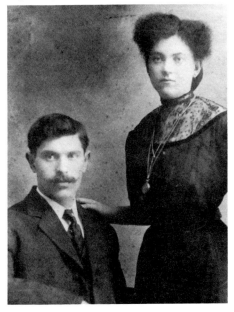

Photographing Textured Objects

To emphasize the texture and surface detail of a coin, shell, or other three-dimensional object, position it so that light rakes across its surface at a low angle and produces shadows that are visible from camera position. It is actually the shadows that make an object's ridges, ripples, and wrinkles apparent. The fewest shadows will be visible when light is coming from close to the camera's lens. More shadows will be visible and texture will be more noticeable when light comes from one side or behind the subject (see opposite). Compared to front lighting, side- or backlighting also increases the impression of volume in an object (see below). After the main or strongest light is in place, you might want to lighten the shadows slightly by adding fill light (see pp. 34–35), not to remove the shadows entirely, but to lighten them a bit so they don't appear excessively dark in the final photograph.

The tiny bumps on a sea anemone are brought into sharp relief by light coming from one side. The lighting also emphasized the round volume of the object.

Sam Laundor.

The direction that light is coming from relative to camera position deter-
mines how much texture will be visible in a photograph of a textured
object. Light that comes from camera position produces the fewest shad-
ows visible in the image and so the least apparent texture (top). Sidelight-
ing or backlighting emphasizes textures because it produces shadows
that are visible from camera position (center and bottom).

Flint Born

Photographing Translucent Objects

Since translucent objects such as decorative glassware and stained glass windows allow light to pass through them, a natural way to photograph them is with light coming from behind. The glowing translucent quality of the subject is enhanced by backlighting, and colored glassware is often displayed in windows for just this purpose. In addition, backlighting eliminates the distracting reflections that are likely to occur when shiny glass is lit from the front. If you are using color film, choose one that matches the source of illumination: daylight film for objects lit by window light, tungsten film for objects illuminated by light bulbs.

If a stained glass window or a piece of glassware fills most of the viewfinder image, use the exposure recommended by the camera's automatic system. But if other very dark or very light areas occupy a large part of the scene, you may want to adjust the exposure. If, for example, a stained glass window is only a small part of the image and is surrounded by dark areas—not an uncommon situation when photographing a stained glass window in a large church—the camera will be influenced by the surrounding darkness and will tend to overexpose the window so it is too light. Use exposure compensation to decrease the exposure 1 or 2 stops. If brilliantly sunlit areas are visible behind glassware in a window, the camera may be overly influenced by the bright light outdoors, underexpose the glassware and make it too dark. Use exposure compensation to increase the exposure about 1 stop unless you want the objects to be silhouetted (see opposite bottom).

In any case, you might try bracketing your basic exposure by making an additional one with 1–2 stops more exposure, and a third exposure with 1–2 stops less. You can choose the best overall exposure after seeing the developed film.

Linda White

Above: light shining through a translucent object not only illuminates the object itself, but can create interesting patterns of light and shadow. Below: bottles in a window are silhouetted against a very bright background. When you want to see details in glassware that is against a very bright background, use exposure compensation to increase the exposure 1–2 stops. To draw attention away from objects outside the window, use a large lens aperture to put the background out of focus.

Bobbi Carrey

Using—or Avoiding— Reflections

Reflections in a shiny surface can be an interesting addition to a photograph, adding reflections of objects in a room (see opposite) or putting bright highlights on a surface. But sometimes reflections are less desirable. When they become a distraction rather than an asset, you can minimize them in several ways. Try standing at a different angle to the glass; if you can find a dark area of a room to reflect in your picture it will be much less prominent than a light area. You can also move in very close to the reflecting surface, so close that your body shields the surface from bright reflections. Reflections from nonmetallic surfaces like a window or shiny wall surface can be reduced by using a polarizing filter on the lens; stand at about a 30–40° angle to the surface, then turn the filter until reflections are minimized. See p. 46 for how to minimize reflections when using flash.

Above left: a museum display case containing meerschaum pipes had reflections of both fluorescent and spot lights in the glass top. Above right: the photographer changed position to move the reflection of the spot lights to the edge of the case. Right: the photographer then used a polarizing filter on the lens, which removed almost all of the reflections from the fluorescent lights.

Bohdan Hrynewych

O

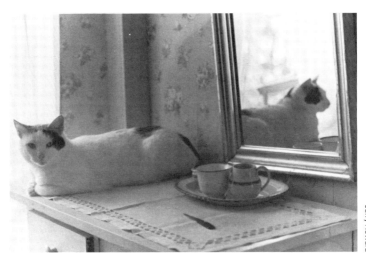

Jerry Howard

You may encounter a puzzling situation when making a photograph with a reflection in it—for example, a scene that includes a mirror with a reflected image (above). Either the area near the mirror will be sharp or the reflection will be sharp, but not both at the same time. The problem is that the reflection in the mirror is really farther away than the surface of the mirror. The distance is measured from the camera to the mirror, back to the reflecting object (see below).

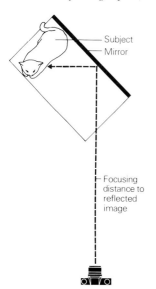

Subject
Mirror

Focusing distance to reflected image

You usually have to decide which is the most important part of the picture and focus on that. Focus on the actual scene if that is most significant. Focus on the reflected image if that dominates. Here, the photographer focused on the bureau top and let the reflection go slightly out of focus. Using a small lens aperture will help to get both sharp, as will stepping back from the reflecting surface or using a shorter focal length lens; any of these will increase your depth of field and make more of the picture sharp.

Still Lifes

Still-life photography generally involves the use of commonplace objects. The photographer sees a texture, shape, color, or pattern of highlight and shadow and captures it on film. The secret to getting good still lifes is *seeing* them, and many possibilities exist ready made if you develop the habit of looking for them. You will want to preview the way the final photograph will look and you can do that best through the viewfinder. Try looking through your viewfinder at various objects around you. Try moving in close enough to isolate them from other objects nearby. Or you can arrange objects yourself; place your camera on a tripod and look at the scene several times through the viewfinder as you arrange and rearrange objects in it.

A ready-made still life: everything was there just as the photograph shows it—old wedding picture, neatly pressed linen cover, light shining softly through the window. It evokes an image of an orderly and slightly old fashioned home.

Joe DeMaio

Barbara M. Marshall

*Ordinary vegetables have an endless variety of shapes and textures.
Above: sidelighting on three heads of lettuce highlights their crinkled
leaves (see lighting textured objects, pp. 98–99). The eye is also drawn to
the three round shapes of their cores, which connect in a triangular
shape that gives an inner solidity to the photograph. Below: white onions
glow brightly against a dark background. A very dark background may
cause your automatic exposure system to overexpose a light-toned subject.
(See pp. 12–13.)*

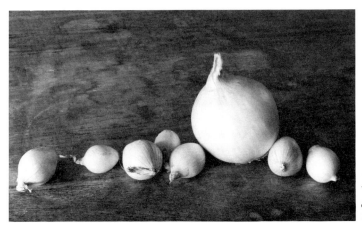

Eric Myvaagnes

Photographing a TV Image

It is easy to photograph scenes directly from your television set—a moon landing, a sports event, or just an unusual or interesting scene. You can also include a TV image as part of a larger scene.

If you have ever tried to photograph a TV image and gotten a dark diagonal band in your picture, the problem was that you used too fast a shutter speed. The electron beam that creates the TV image takes about 1/30 sec to complete a scan, but with a single-lens reflex camera you must use a shutter speed of 1/8 sec or slower to record a complete scan. With shutter-priority cameras, simply set the correct shutter speed directly; with aperture-priority cameras, select an aperture setting that gives you a 1/8-sec shutter speed readout in your viewfinder. (If your camera gives no information about shutter speed so that you cannot set it to 1/8 sec, try setting the aperture to f/11. In most cases, this will produce a shutter speed of 1/8 sec or slower.)

If the television image itself is your major interest, adjust the contrast control to less than normal. Set the brightness control so that you can see details in both light and dark areas. With color film, adjust the color to its optimum. To avoid room reflections on the screen, turn off lights, draw curtains, or move close enough to block reflections with your body. Meter the screen by moving close enough to fill the viewfinder with the TV image. With a 1/8-sec shutter speed, you should place your camera on a tripod or other support to prevent blurring the image with camera motion during the exposure.

If you want the TV to be part of a larger scene you may want to increase the light level of the room. Most rooms are darker than the TV screen, so if your exposure is correct for the television, the room will be very dark in the photograph. If it is correct for the room, the television will be very light.

If you are using color film, select one for daylight use. A CC4OR red filter over the camera lens will improve the color balance by reducing the blue-green cast of the television image. A universally balanced film like Kodacolor 400 Film, which produces a reasonably good color balance with a variety of light sources, does not require a filter.

Terry McKoy

*To get a clear photograph of a TV image (left) use a shutter speed of
1/8 sec or slower. Speeds faster than 1/8 sec will produce a dark band
across the screen (right). To get the correct exposure for the screen, move
close enough so that it fills your viewfinder image.*

*Most TV images are brighter than the rooms they are in, so the TV image
will be relatively light if the exposure for the room is correct. Here the
photographer was more interested in the children than in the television
image. She turned on all the room lights to get it as bright as possible, but
metered the room rather than the screen for the exposure.*

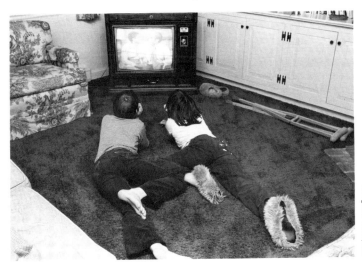

Margaret Thompson

7 A Picture Story

Fredrik D. Bodin

A Picture Story

How many pictures tell a story? How many do you need to describe a situation or record an event? Sometimes only one is needed: the bride and groom leaving the church as guests throw rice can sum up the essence of a wedding day. Usually, however, a series of pictures is used: the bride and attendants before the wedding, a shot during the ceremony, cutting the cake, dancing, throwing the bouquet.

If you are interested in making picture stories:

Go where the action is and take your camera with you. Obviously you won't get the story if you are not there to record it. If you don't take your camera, or if you don't have it ready to use, you'll be missing pictures and all you'll have is a story about the great shot that got away.

Take many pictures. Keep your shutter, and your camera position, moving. Automatic exposure makes it easy to concentrate on the subject rather than camera controls. Try different exposure combinations if the light is unusual. The more pictures you take, the more you will have to choose from during editing. Most professionals feel that getting one good picture out of every ten they take is an excellent ratio.

Take details as well as overall shots. Vary your pictures so you don't shoot everything from the same medium distance. Close shots of someone's expression, signs, historical markers, the bride's bouquet, a single holiday ornament, the life preserver marked with the name of the ship: the possibilities are endless and they will add variety and interest to your story.

Edit your pictures ruthlessly. You can dramatically improve a story by selecting only those pictures that tell the story powerfully and in meaningful sequence. Avoid five almost identical shots of the same famous landmark; it's the fastest way to make your audience lose interest.

Fredrik D. Bodin

A useful editing tool when making picture stories is the contact sheet, an 8 × 10 inch photographic print with an entire roll of negatives printed on the sheet. While small, the pictures are big enough so that you can decide which are good enough to enlarge (the actual size of the contact sheet is about twice as big as shown here). If you are using negative film, finding out which pictures to print this way is less expensive than enlarging all your shots. You can request a contact sheet when you have your film processed. If you are shooting slides, there is no need for a contact sheet, but you should go through the same process of selection by laying out your slides on a slide sorter (see pp. 124–125).

A Wedding Story

Although many weddings involve professional photographers, you may wish to photograph at a wedding yourself or add your own photographs to those the professional will supply the newlyweds. If a professional is on the job, do your shooting so you don't get in front of his or her camera or cause delays. Wedding pictures are broadly divided into portraits of individuals or groups (below and opposite) and candids (pp. 114–115).

Formal portraits serve to introduce the people involved in the ceremony. The bridal party, parents, and close relatives are generally represented. Depending on the schedule, formal portraits can be taken at the altar before or after the ceremony or at the reception against an attractive background. Some standard formal portrait shots include:

> Bride alone.
> Bride and groom. Customarily bride is on the groom's right.
> Bride and groom with their parents. Mothers next to their respective children, fathers next to them.
> Bride and groom with attendants. Maid of honor next to bride, best man next to groom, other attendants next to them.
> Other shots as desired: bride with flower girl and ring bearer, bride and groom with grandparents, etc.

Peggy Cole

Janice Fullman

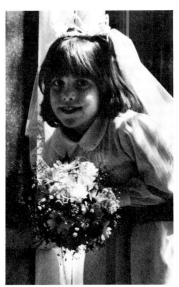

Jean Shapiro

Opposite: the bride formally posed with her dress carefully arranged is one of the standard portraits taken at a wedding. Above: move in close for some portrait shots. Expressions will be easier to see and the picture will have a more intimate feeling. Left: portraits don't have to be formally posed. A casual pose can often produce a more relaxed expression.

More About Weddings

Candids at weddings capture the spirit and joy of the occasion and are just as important as formal portraits. Listed below are some standard wedding candid shots. Individual taste is important here because some couples prefer entirely unposed pictures, while others want a picture of the bride throwing the bouquet, even if the action has to be repeated for the benefit of the photographer.

> Mother arranging bride's veil
> Bridesmaids placing the garter on bride's leg
> Bride pinning boutonniere on her father's lapel
> Best man adjusting groom's boutonniere
> Ushers escorting special guests to their seats
> Father and the bride beginning their walk down the aisle
> Bride and groom at altar during ceremony
> Bride and groom walking back down the aisle after ceremony
> The receiving line, guests
> Cutting the wedding cake, toasting
> Bride and groom and others dancing
> Throwing the bouquet and garter
> Bride and groom departing

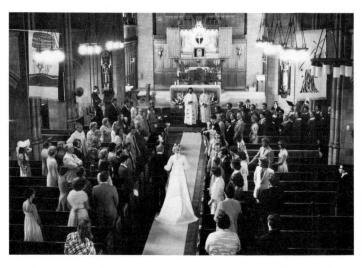

Elizabeth Hamlin

Right: use a fast shutter speed, at least 1/125 sec for unposed candids of action as it is happening. Below: it is safest to shoot even posed candids at a fast shutter speed, especially when two or more people are in the picture. Weddings often move from indoors to outdoors and back. Daylight-balanced color film will give good colors where daylight predominates or with flash, and a church interior will have a pleasant golden tone if candles or tungsten lamps are lit. If many scenes are lit predominantly by tungsten light, you can switch to tungsten-balanced film.

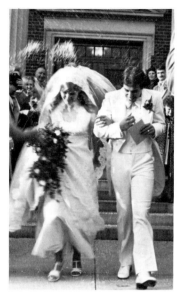

Rick Ashley

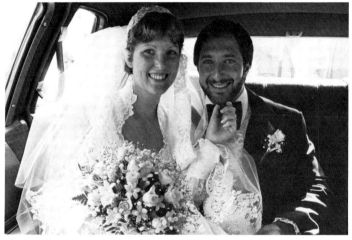

Mike Rizza

◄ *During the ceremony, a balcony is an excellent place for an overall view. If there is no balcony, the back of the center aisle will usually give a view of the bride and groom at the altar. Expect a relatively long exposure, so plan on using a tripod or bracing your camera somehow. Flash is generally forbidden during the actual ceremony and in most cases you will be too far away for it to be effective anyway. You can often get closer during the ceremony at less traditional weddings, but flash may still be intrusive.*

Other Ceremonies

Ceremonies mark coming of age, accolades, new membership, and other important events. Try, if you can, to seek out pictures that will capture the essence and the spirit of the ceremony without intruding. An electronic flash is useful for capturing good pictures at ceremonies; it provides extra light so you don't have to ask people to hold still for a long exposure when light is dim.

Right: avoid if possible the grip-and-grin shot that is so often taken at award ceremonies. Sometimes this is, in fact, the only event of pictorial significance at a ceremony, but often you can find or set up a shot that will be more meaningful to the participants and to those who see your picture. Below: a group of men demonstrate *that they gave blood rather than simply smile and accept a certificate.*

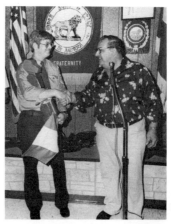

Mike Rizza

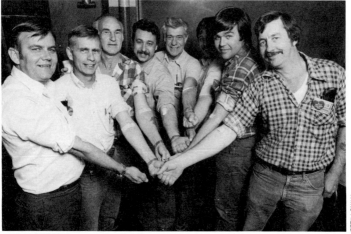

Mike Rizza

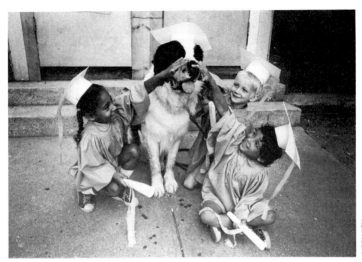

Above: giving people a prop or something to do can make an awards picture look less posed. Below: the photographer supplemented the existing light with flash, bouncing it off the wall in front of the boy so that it appeared to come from the candles.

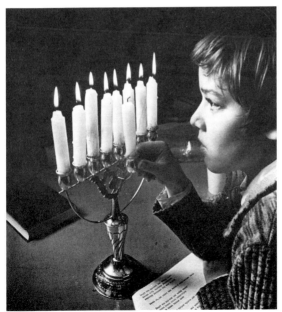

Children Growing Up

Stories can be told across time as well as about a single event. Pictures of the same child when he or she is a newborn infant, an older baby, a toddler, and a young child will tell a priceless story when the child is grown.

Fredrik D. Bodin

Bohdan Hrynewych

Jerry Howard

Fredrik D. Bodin

A Story About Sarah

A story can be as simple as five pictures of a child demonstrating the art of transferring liquids from one container to another.

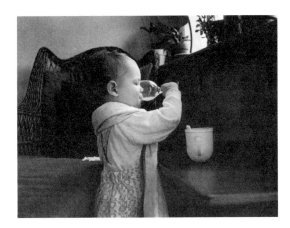

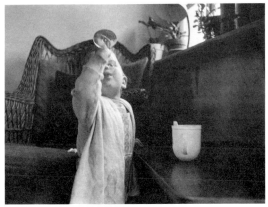

8 Preserving and Showing Your Pictures

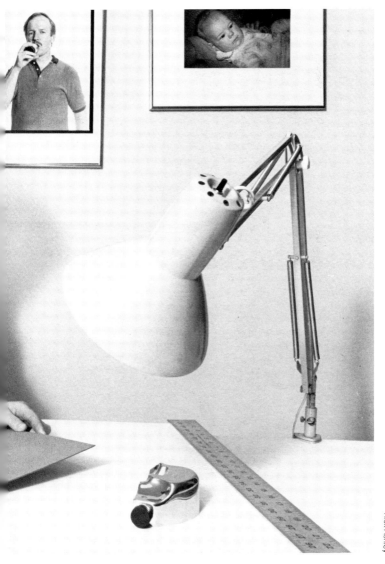

Organizing and Storing Slides

Sorting and organizing your slides soon becomes necessary and is easy if you have an organizational scheme and some basic pieces of equipment. The categories for organizing slides—or any pictures—are a matter of personal choice. Some people arrange their slides chronologically. Many professionals file theirs according to topics such as animals, flowers, children and so on, so they can furnish clients with a choice of pictures on demand. Some people organize by event: "Caribbean Cruise, 1976," or "New Year's Eve, 1980." Whichever scheme you select, when you are trying to locate a particular slide, any method is better than none.

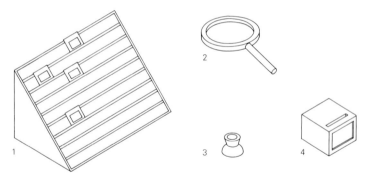

*A **slide sorter** (1), a translucent surface with a light behind it, is useful for organizing slides. Ridges keep the slides from falling off the inclined surface. Horizontal models are also available. A **magnifying glass** (2) or **loupe** (3) provides an enlarged view of individual slides. A **table-top slide viewer** (4) provides a somewhat enlarged projection, convenient for viewing a few slides at a time. (See projectors and slides on p. 127.)*

Storing and protecting your slides properly will guard against their two worst enemies: heat and humidity. Excess amounts of these can cause slide mountings to warp and separate, fungus to grow on the emulsion, colors to fade, and other ills. Don't store slides over radiators or near sinks. Avoid stacking them in loose piles, because the edges of the cardboard mountings can scratch the slide image.

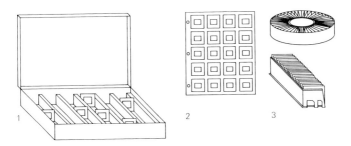

Slide boxes (1) with slotted rows store many slides compactly. *Slide pages (2)* of transparent plastic can be bound in notebooks, and allow you to look at slides without removing them from the pages. A more expensive but convenient way to store slides you project frequently is in the *trays, drums or cubes (3)* used for projection.

Cleaning slides and repairing slide mounts is an infrequent but important task. Handle slides by their mounts so that fingerprints don't accumulate on the delicate image surface and store them as much as possible away from dust. But some cleaning is inevitable, and you should use materials suitable for contact with film. Cracked or peeling mountings can be replaced with mounts available in photo stores.

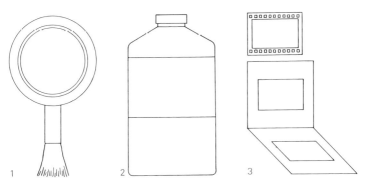

Photographic stores sell materials suitable for cleaning slides. A soft brush (1) will handle most cleaning chores. If you need to clean a slide of more than simply dust, use a *cleaning solution (2)* designed for use on film. *Blank slide mounts (3)* of cardboard, plastic, or glass are available to replace an old slide mount. Some photographers who prefer plastic or glass mounts get their slides returned developed but unmounted, then do all their own mounting.

Showing Slides

If you take color slides, a slide show is a good way to show your pictures to several or many people at one time. A brief show, with superior slides that are well organized and presented, is far preferable to a long, drawn-out exhibition of an entire slide collection, complete with long explanations for each slide. You are probably more interested in the history of each slide than is the audience, so keep the show unified, brief, and good. If you do, people will look forward to seeing your slides rather than changing the subject when you mention the pictures you took on vacation.

Suggestions for Better Slide Shows

Edit your slides. A key to good images is knowing which slides *not* to show. One of the major skills of a professional photographer is taking lots of pictures and throwing the bad ones away.

Plan your show. If possible, each show should have some theme or framework to unite the slides. An event, such as a vacation or special ceremony or holiday, can provide the unification (see pp. 108–121). Or you can show your best pictures of flowers, children, or other subjects. Plan your presentation so that it has a beginning, middle, and end.

Title slides may help. Don't make a title slide merely for the sake of having one, but sometimes a lead-off title slide helps set the mood for the show to follow and lets the audience know what to expect. Title slides can be photos of signs or roadmaps that indicate the location of a trip or event, a copy of a wedding invitation, or other authentic material. You can also construct your own title material with lettering sets available at photo or art supply stores.

Make your audience comfortable. People seated comfortably in a chair with a good view of the screen will probably react more positively than those leaning against a wall in a hallway. Place as many people as possible in a direct line with the screen.

Technical details. Clean the projector, align it correctly with the screen, and load and focus it before the audience is seated. Have a spare projector lamp handy. Don't begin and end the show with a glaring white screen; turn on the projector lamp with the first slide in place, then turn the room lights back on with the last slide still showing. Make certain the room is dark enough for good viewing.

Slide Show Equipment

*The easiest way to show slides is simply to talk about the slides (or remain silent) as you advance the projector from one slide to the next. The **projector** shown has a detachable tray into which you can load from 80 to 140 slides. A **remote control lead** lets you advance, reverse, and focus slides without having to be right next to the projector. A **slide projector table** can be a useful accessory, especially if you often show slides away from home.*

More complicated presentations could include a prerecorded sound track including narration, music, and sound effects. You can tape this, then change the slides yourself at the appropriate place during the tape. A sound synchronizer connects to a slide projector; it lets you record a sound track on one channel and on another channel inaudible signals that automatically advance the slides. A dissolve unit coordinates two or more projectors, blending one slide into the next, superimposing them or producing other special effects.

Lenses of different focal lengths are available for projectors. The normal-focal-length lens sold with a projector fills a screen in an average-sized room. A shorter focal length gives a big picture in a small room. You may need a long focal length in a very large room where the screen is far away. Zoom lenses are also available that let you adjust the size of the projected image without moving the projector.

*Slides may be satisfactorily projected on a white wall or other flat surface, but a **screen** will reflect the light better and preserve the color brilliance and clarity of your slides. Three kinds of screen surfaces are available. A glass-beaded surface produces a very bright image to those seated directly in front of the screen; people off to the side see a darker, less satisfactory image. A silver lenticular screen is also bright and is a good surface to use if the room can't be darkened. A mat white screen is not as bright but can be viewed from off to the side as well as in front.*

Displaying Prints

The same basic storage conditions that apply to slides are suitable for prints and negatives: avoid extremes of heat and humidity that can cause fading, fungus growth, and other damage. Although slides and negatives are generally stored in the dark, prints have another danger to face: light. Strong light, particularly direct sunlight, makes prints fade, so ideally if you leave prints on permanent display, hang them away from very bright light. If you can't avoid bright light, you can rotate prints periodically. Some ways of displaying prints are shown below and opposite.

Framing is still the favored way of displaying large-sized prints and can be used for smaller prints as well. Most ready-made frames are in standard sizes such as 5 × 7, 8 × 10, or 11 × 14, but you can assemble or have made any size frame you like. Look for framing supplies in large art supply or photo stores or in shops that specialize in framing. Prints to be framed are often mounted first (see pp. 130–131).

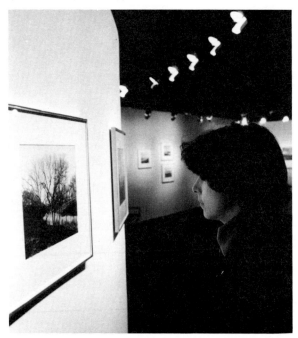

Rick Ashley

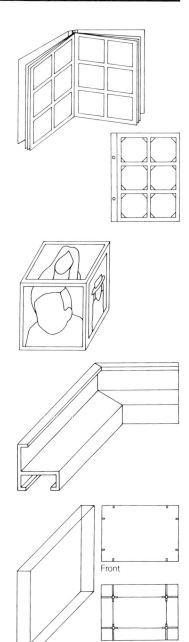

The photo album has been a popular means of storing and displaying small photographs ever since the 19th century when people collected visiting-card-size prints called cartes de visite. Some albums have plastic pockets into which prints slip. If prints must be mounted onto paper, use photo corners rather than cellophane tape, rubber cement, glue, or other adhesives. The prints easily slip into and out of the corners and there is no risk of adhesives eventually discoloring the print.

Plexiglas picture cubes, flip racks, and similar devices make it convenient to display a few small prints on a coffee table or desk. Avoid print fading by keeping them out of direct sun or strong lamplight.

Precut metal frames (shown opposite assembled) are sold in various lengths, two to a package. You buy two packages in the lengths you need to make the frame you want. Only a screwdriver is needed to put the frame together. Glass, mat, photo, and backing are held tightly against the lip of the frame.

All-plastic frames and **clip frames** are alternatives to the standard glass and frame design. Both eliminate the need for wooden or metal frames around the edges.

Front

Back

Overmatting and Mounting Prints

Mounting attaches the back of a print to a heavy-weight piece of cardboard. This keeps the print flat for viewing and protects it from creasing. Overmatting or matting a print involves cutting an opening the size of the print in a larger piece of board. An overmat keeps the surface of the print from touching the glass in a frame, which is desirable because under pressure the print may adhere to the surface of the glass.

For both mounting and matting, the ideal material for valued prints is archival or museum quality, high-cellulose mount boards because they are free of the acidity that may eventually discolor a print. For short-term display or less valuable prints, ordinary mounting boards are less expensive and widely available in art and framing supply stores.

Attaching the print to the mount board may be done in several ways. Attaching a print with hinges is shown opposite. Ideally the tape should be acid-free linen tape available where good quality mount board is sold. Prints can also be slipped into photo corners. The corners or hinges are hidden when the print is overmatted. Dry mounting has been a popular way to mount prints for many years. A waxy sheet of paper impregnated with an adhesive is placed between the print back and the mount board. When heated (a dry mount press is most convenient but a home iron can be used) the adhesive melts and bonds the print to the board. Some types of mounting materials adhere on contact or with pressure instead of requiring heat. Avoid cellulose tape, masking tape, brown paper tape, or ordinary glues; these are very likely to discolor the print over time.

Attaching a Print to a Mount with Hinges

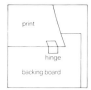

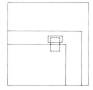

A folded hinge is hidden when print is in place.

A folded hinge can be reinforced by a piece of tape.

A pendant hinge is hidden if an overmat is used.

Overmatting a Print

Measure the image area of the print. Here: 7 × 9 in. Add the desired margin around the print. Here: 2 in on each side. Add the margins to the print size:
$$2 + 7 + 2 = 11$$
$$2 + 9 + 2 = 13$$

Cut two boards 11 × 13 in, one for the backing mount, one for the overmat. Use a sharp mat knife braced against a metal straightedge like a heavy metal T-square or ruler.

Mark the back of one board with the image area of the print, allowing for the margins. Cut along the lines using the mat knife or a mat cutter, a device that can clamp a cutting blade at an angle to cut a beveled edge.

Position the print on the backing mount underneath the overmat. Attach the print to the backing mount (see opposite). The frame will hold the overmat in place over the print and mount.

Useful Terms

Prepared by Lista Duren

angle of view The amount of a scene that can be recorded by a particular lens; determined by the focal length of the lens.

aperture The lens opening formed by the iris diaphragm inside the lens. The size is variable and is controlled by the aperture ring on the lens.

aperture-priority mode An automatic exposure system in which the photographer sets the aperture (f-stop) and the camera selects a shutter speed for correct exposure.

ASA A number rating that indicates the speed of a film. Stands for American Standards Association. See also **film speed.**

automatic exposure A mode of camera operation in which the camera automatically adjusts the aperture, shutter speed, or both for proper exposure.

automatic flash An electronic flash unit with a light-sensitive cell that determines the length of the flash for proper exposure by measuring the light reflected back from the subject.

bounce light Indirect light produced by pointing the light source away from the subject and using a ceiling or other surface to reflect the light back toward the subject. Softer and less harsh than direct light.

bracketing Taking several photographs of the same scene at different exposure settings, some greater than and some less than your first exposure, to ensure a well-exposed photograph.

color balance The overall accuracy with which the colors in a color photograph match or are capable of matching those in the original scene. Color films are balanced for use with specific light sources.

contrast The difference in brightness between the light and the dark parts of a scene or photograph.

contrasty Having greater-than-normal differences between light and dark areas.

cool Toward the green-blue-violet end of the visible spectrum.

daylight film Color film that has been balanced to produce natural-looking color when exposed in daylight. Images will look reddish if daylight film is used with tungsten light.

depth of field The distance between the nearest and farthest points that appear in acceptably sharp focus in a photograph. Depth of field varies with lens aperture, focal length, and camera-to-subject distance.

diffused light Light that has been scattered by reflection or by passing through a translucent material. Produces an even, often shadowless, light.

DIN A number rating used in Europe that indicates the speed of a film. Stands for Deutsche Industrie Norm. See also **film speed.**

direct light Light shining directly on the subject and producing strong highlights and deep shadows.

electronic flash (strobe) A camera accessory that provides a brilliant flash of light. A battery-powered unit requires occasional recharging or battery replacement, but unlike a flashbulb can be used repeatedly.

exposure 1. The act of allowing light to strike a light-sensitive surface. 2. The amount of light reaching the film, controlled by the combination of aperture and shutter speed.

exposure meter (light meter) A device built into all automatic cameras that measures the brightness of light.

exposure mode The type of camera operation (such as manual, shutter-priority, aperture-priority) that determines which controls you set and which ones the camera sets automatically. Some cameras operate in only one mode. Others may be used in a variety of modes.

film speed The relative sensitivity to light of photographic film. Measured by ASA, DIN, or ISO rating. Faster film (higher number) is more sensitive to light and requires less exposure than does slower film.

filter A piece of colored glass or plastic placed in front of the camera lens to alter the quality of the light reaching the film.

fisheye lens An extreme wide-angle lens covering a 180° angle of view. Straight lines appear curved at the edge of the photograph, and the image itself may be circular.

flare Stray light that reflects between the lens surfaces and results in a loss of contrast or an overall grayness in the final image.

flat Having less-than-normal differences between light and dark areas.

focal length The distance from the optical center of the lens to the film plane when the lens is focused on infinity. The focal length is usually expressed in millimeters (mm) and determines the angle of view (how much of the scene can be included in the picture) and the size of objects in the image. The longer the focal length, the narrower the angle of view and the more that objects are magnified.

focal plane See **film plane.**

frame 1. A single image in a roll of film. 2. The edges of an image.

f-stop (f-number) A numerical designation (f/2, f/2.8, etc.) indicating the size of the aperture (lens opening).

ghosting 1. Bright spots in the picture the same shape as the aperture (lens opening) caused by reflections between lens surfaces. 2. A blurred image combined with a sharp image in a flash picture. Can occur when a moving subject in bright light is photographed at a slow shutter speed with flash.

guide number A number on a flash unit that can be used to calculate the correct aperture for a particular film speed and flash-to-subject distance.

hand hold To support the camera with the hands rather than with a tripod or other fixed support.

hot shoe A clip on the top of the camera that attaches a flash unit and provides an electrical link to synchronize the flash with the camera shutter.

ISO A number rating that combines the ASA and DIN film speed ratings. Stands for International Standards Organization. See also **film speed.**

lens hood (lens shade) A shield that fits around the lens to prevent extraneous light from entering the lens and causing ghosting or flare.

light meter See **exposure meter.**

long-focal-length lens (telephoto lens) A lens that provides a narrow angle of view of a scene, including less of a scene than a lens of normal focal length and therefore magnifying objects in the image.

manual exposure A nonautomatic mode of camera operation in which the photographer sets both the aperture and the shutter speed.

negative 1. An image with colors or dark and light tones that are the opposite of those in the original scene. 2. Film that was exposed in the camera and processed to form a negative image.

normal-focal-length lens (standard lens) A lens that provides about the same angle of view of a scene as the human eye and that does not seem to magnify or diminish the size of objects in the image unduly.

open up To increase the size of the lens aperture. The opposite of stop down.

overexposure Exposing the film to more light than is needed to render the scene as the eye sees it. Results in a too dark (dense) negative or a too light positive.

pan To move the camera during the exposure in the same direction as a moving subject. The effect is that the subject stays relatively sharp and the background becomes blurred.

positive An image with colors or light and dark tones that are similar to those in the original scene.

print An image (usually a positive one) on photographic paper, made from a negative or a transparency.

reciprocity effect (reciprocity failure) A shift in the color balance or the darkness of an image caused by very long or very short exposures.

reversal film Photographic film that produces a positive image (a transparency) upon exposure and development.

short-focal-length lens (wide-angle lens) A lens that provides a wide angle of view of a scene, including more of the subject area than does a lens of normal focal length.

shutter The device in the camera that opens and closes to expose the film to light for a measured length of time.

shutter-priority mode An automatic exposure system in which the photographer sets the shutter speed and the camera selects the aperture (f-stop) for correct exposure.

shutter speed dial The camera control that selects the length of time the film is exposed to light.

silhouette A dark shape with little or no detail appearing against a light background.

single-lens reflex (SLR) A type of camera with one lens which is used both for viewing and for taking the picture.

slide A positive image on a clear film base viewed by passing light through from behind with a projector or light box. Usually in color.

SLR See **single-lens reflex.**

standard lens See **normal-focal-length lens.**

stop 1. An aperture setting that indicates the size of the lens opening. 2. A change in exposure by a factor of two. Changing the aperture from one setting to the next doubles or halves the amount of light reaching the film. Changing the shutter speed from one setting to the next does the same thing. Either changes the exposure one stop.

stop down To decrease the size of the lens aperture. The opposite of open up.

strobe See **electronic flash.**

synchronize To cause a flash unit to fire while the camera shutter is open.

telephoto lens See **long-focal-length lens.**

35mm The width of the film used in the cameras described in this book.

transparency See **slide.**

tripod A three-legged support for the camera.

tungsten film Color film that has been balanced to produce natural-looking color when exposed in tungsten light. Images will look bluish if tungsten film is used in daylight.

underexposure Exposing the film to less light than is needed to render the scene as the eye sees it. Results in a too light (thin) negative or a too dark positive.

vignette To shade the edges of an image so they are underexposed and dark. A lens hood that is too long for the lens will cut into the angle of view and cause vignetting.

warm Toward the red-orange-yellow end of the visible spectrum.

wide-angle lens See **short-focal-length lens.**

Index

Prepared by Lisbeth Murray

Index Errata

The index on pages 136-137 is incorrect. Please use this one in its place.